ODE TO A CEMETERY

Bethany Eden Jacobson

Text by Cole Swensen

HIRMER

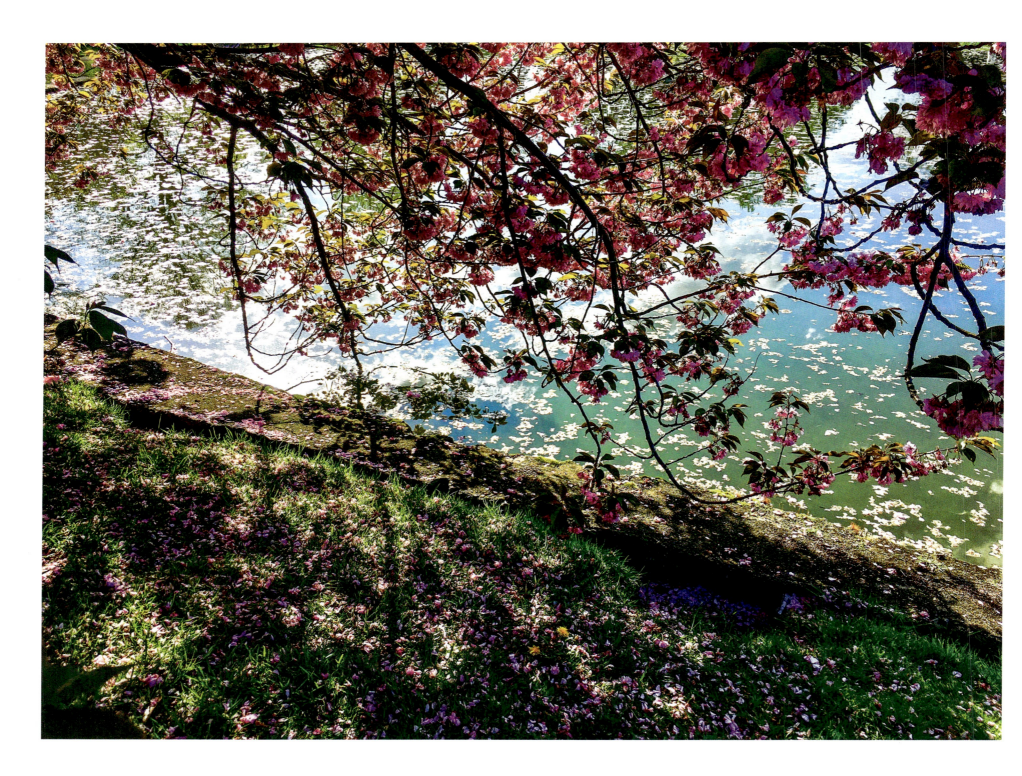

Dedicated to those whom I have loved and lost.
You are embedded in these pages.

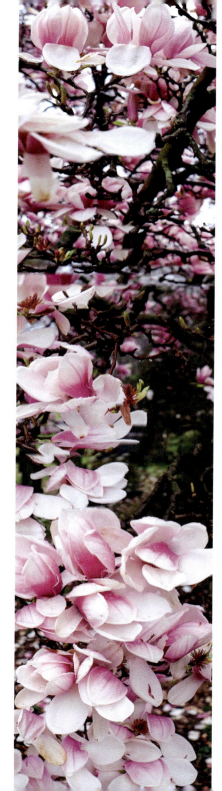

A Few Words

by Bethany Eden Jacobson

When the pandemic shut down New York City, Green-Wood became a refuge, a place to find solace, to escape the confinement and isolation of my apartment. During my many meditative walks, I photographed the statuary and the century-old trees, and rediscovered how important nature is to the human spirit. Attracted to the symbolism of the Christian iconography, the worn surfaces of the gravestones spoke to me. Time and the elements have left their markings, inscribing their own silent history, expressing a dimension that transcends their religious purpose.

Mortality is naturally present in any burial place, but I never experienced Green-Wood as morbid or depressing. Rather, I found it to be a magical, urban oasis where I could release my grief, relish my solitude, and rejoice in the transcendent power of a green oasis in a concrete city. I hope my photographs convey the sense that death is a natural ending. While the rituals and places we bury the dead may vary according to the cultural, social, and geographical particulars, this special place deepened my awareness of our common mortality and the ephemeral nature of life.

As the book evolved, it led me on a journey to learn paper-making. I wanted to convey the tactility of Green-Wood —the decaying statuary, magnificent trees, changing seasons, and sometimes surreal skies of this verdant oasis in Brooklyn. Embedding select images in a textured handmade surface allowed me to dramatize the solemnity and decaying surfaces of the female statuary.

This book is a dreamscape, a confluence of the ephemeral and the visceral, conveying the tranquility, solitude, and enchantment that I experienced on my many journeys through Green-Wood Cemetery. My deep gratitude to Cole Swensen, Roy Skodnick, and Art Presson for their contribution.

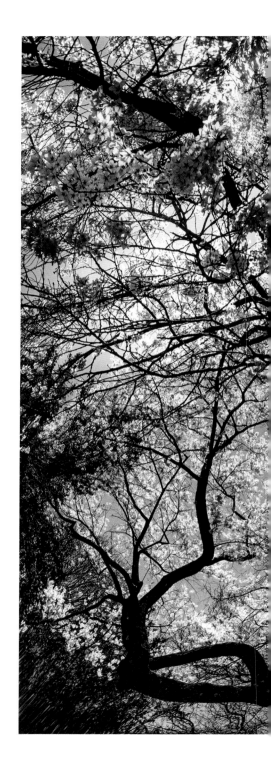

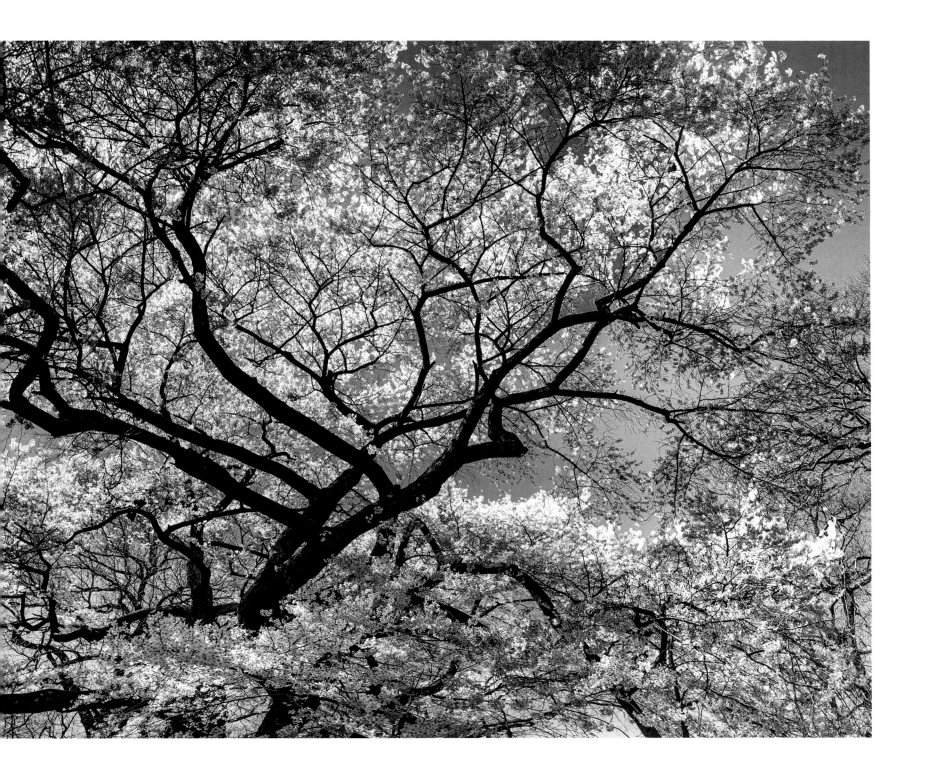

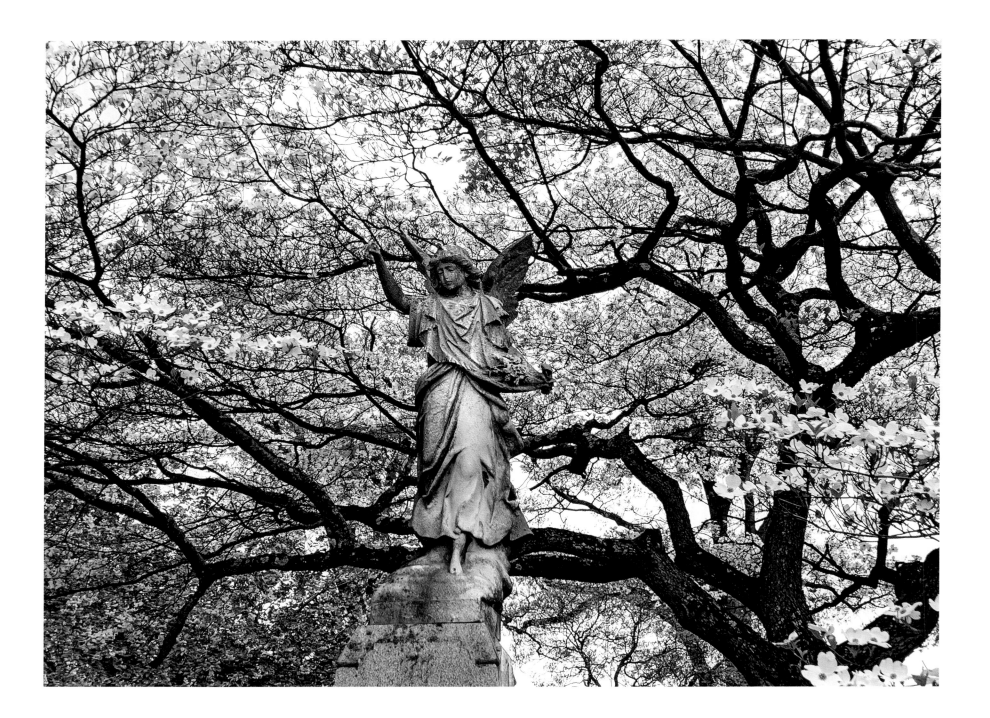

Green-Wood's Magnificence
New York City's First Rural Cemetery
by Art Presson

For almost 200 years, Green-Wood Cemetery has provided a beautiful and harmonious space where the living honor the dead. It also ushered in a new way of defining and thinking about death. Before the rural cemetery movement of the 1830s, most burial places in America were connected to churches and known simply as graveyards. The word cemetery, on the other hand, derives from Ancient Greek *koimeterion* for sleeping place, suggesting a place of peaceful rest. This was Green-Wood's founding principle.

In the early nineteenth century, American cities like Baltimore, Philadelphia, New York City, and Boston were growing rapidly. Graveyards were reaching capacity. Noxious fumes from shallow graves in Manhattan amidst a yellow fever outbreak in 1822 led the city fathers of Manhattan to outlaw burials south of Canal Street in 1832. Yet proximity to the departed was important. Just across the East River in South Brooklyn lay an ideal parcel of land formed by the glacial moraine.

Green-Wood's founder, Henry Evelyn Pierrepont (1808–1888), was appointed to Brooklyn's Board of Commissioners in 1833. Pierrepont was assigned by the board the task of laying out a street grid for the new city that would include a place for a rural cemetery. He remembered the beautiful, hilly landscape in South Brooklyn from his boyhood days of horseback riding. While impractical for commercial or residential use, the location possessed magnificent vistas of New York Harbor as the highest elevation in Brooklyn. Pierrepont set aside the hilly area above the Gowanus Creek. This romantic site was ideal for a landscaped cemetery.

Pierrepont met with David Bates Douglass to survey the land. These two men were the visionary designers of Green-Wood. As an engineering professor at West Point, Douglass had recently surveyed and proposed the route for the massive Croton Aqueduct to deliver clean water to New York City. Pierrepont was also inspired by his travels to the historical cemeteries in France and Italy, as well as Mount Auburn Cemetery in Cambridge, Massachusetts, the first of America's rural cemeteries.

Founded in 1838 as the third rural cemetery in America, Green-Wood was a non-sectarian, park-like, landscaped cemetery that would serve the families of New York City, Brooklyn, and beyond. At Green-Wood they believed it was essential to preserve the verdant landscape, rich with majestic trees and natural ponds. Roads were carved out, following the natural swales in the land, and ground was judiciously cleared to allow for burials. Together the rolling hills, vistas, dense woods, winding carriage roads, and footpaths became defining characteristics of Green-Wood.

"Genius loci" (the genius of place) was a favorite phrase of Frederick Law Olmsted (1822–1903), who is often referred to as the father of landscape architecture. It refers to the unique ecological and spiritual qualities Olmsted believed every site possesses. Douglass and Pierrepont both recognized the genius loci of Green-Wood's future location. In 1866, *The New York Times* proclaimed, "It is the ambition of every New Yorker to stroll Fifth Avenue, take his airing in the [Central] Park, and to sleep with his fathers in Green-Wood." Before the Brooklyn Bridge was completed in 1883, Manhattanites traveled to Green-Wood by ferry across the East River. The trip refreshed the soul and provided an opportunity to feel the restorative power of nature.

Interest in the afterlife and resurrection inspired new burial iconography in the rural cemetery. Macabre skulls and crossed bones had been common iconography in graveyards. However, in rural cemeteries, such morbid graveyard symbols were replaced by gentle angels pointing toward heaven, draped columns, intertwining garlands, and tree stumps cut short, all common to Victorian funerary art. Stone carving was at a high point. Hand engraving was the only method available to letter headstones. White marble was the preferred sculpting stone, as it could be carved, rendering features of great delicacy.

The success of Green-Wood Cemetery in attracting large crowds was an inspiration for Central Park and the park movement of the nineteenth century. In 1848 Andrew Jackson Downing wrote, "Judging from the crowds of people in carriages and on foot which I find constantly thronging Green-Wood . . . I think it is plain enough how much our citizens of all classes would enjoy public parks on a similar scale." Jackson's comment was prescient. By 1858, Manhattan had Central Park, and twenty-three years later, Brooklyn's Prospect Park opened to the public. The convenience of the new parks for the living was immediately popular and took the pressure off of cemeteries to function as parks.

During the Great Depression, the days of grandiose monuments and magnificent mausoleums declined. All the while, however, the stately trees continued to grow and the memorials gained a patina. Today, the appeal of this magnificent green space in a densely populated city has become more important than ever. A visitor soon forgets that he or she is in urban Brooklyn and marvels at the sheer size of the place. At 478 acres, Green-Wood has one of the largest, oldest, and most diverse collections of trees in the Northeast. It boasts over 8,600 trees, representing 830 species and hybrids, 60 taxonomic families, and 162 genera. Of note are the black oak, sassafras, cucumber magnolia, linden, tulip, and Himalayan pine.

In 2015, Green-Wood received accreditation as a Level III Arboretum. As a resource and asset for its surrounding community, the cemetery now welcomes over 450,000 visitors every year. It has also become a leader in climate resilience through its environmental programs, which include pollinator meadows, reduced use of fossil-fuel-burning lawn mowers and innovative stormwater initiatives.

On the occasion of Green-Wood's 175th anniversary in 2013, Pulitzer Prize-winning historian Debbie Applegate wrote, "For the living, Green-Wood provided one of the first hand-crafted green spaces where Americans could freely and without shame explore their deepest emotions, as well as seek pleasure, inspiration and the delights of fresh air and exercise." In our recent shared experience of a global pandemic, Brooklynites once again sought the pleasure of long, outdoor walks in the cemetery and came in record numbers. Green-Wood continues to be one of the outstanding treasures of New York City—for those who pay homage to the dead, as well as for the thousands who admire its glorious memorials, romantic aspirations, and grand vistas.

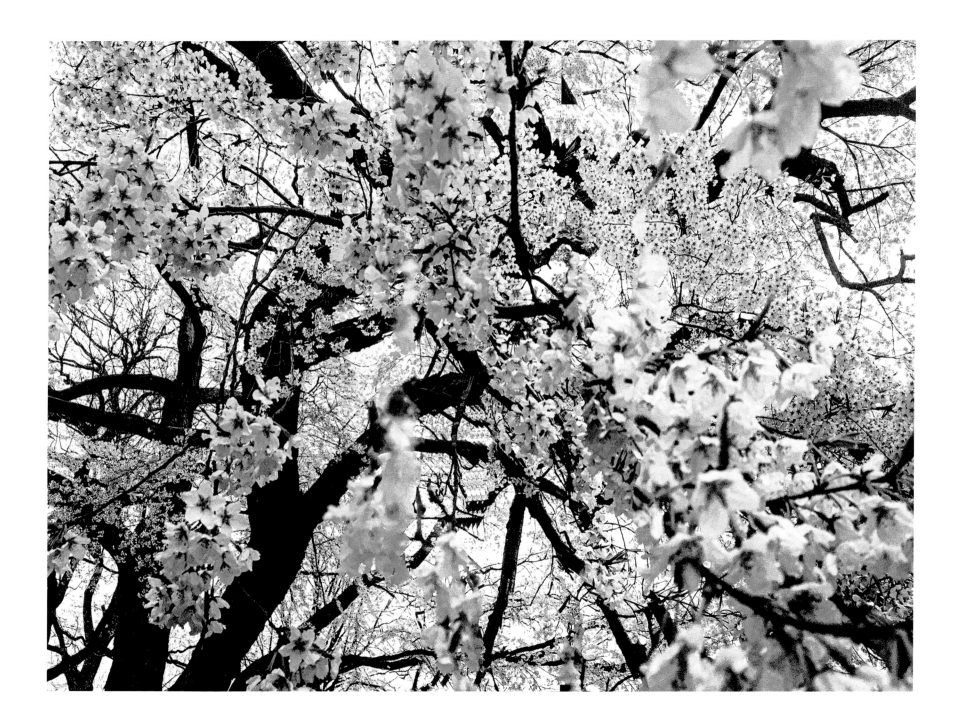

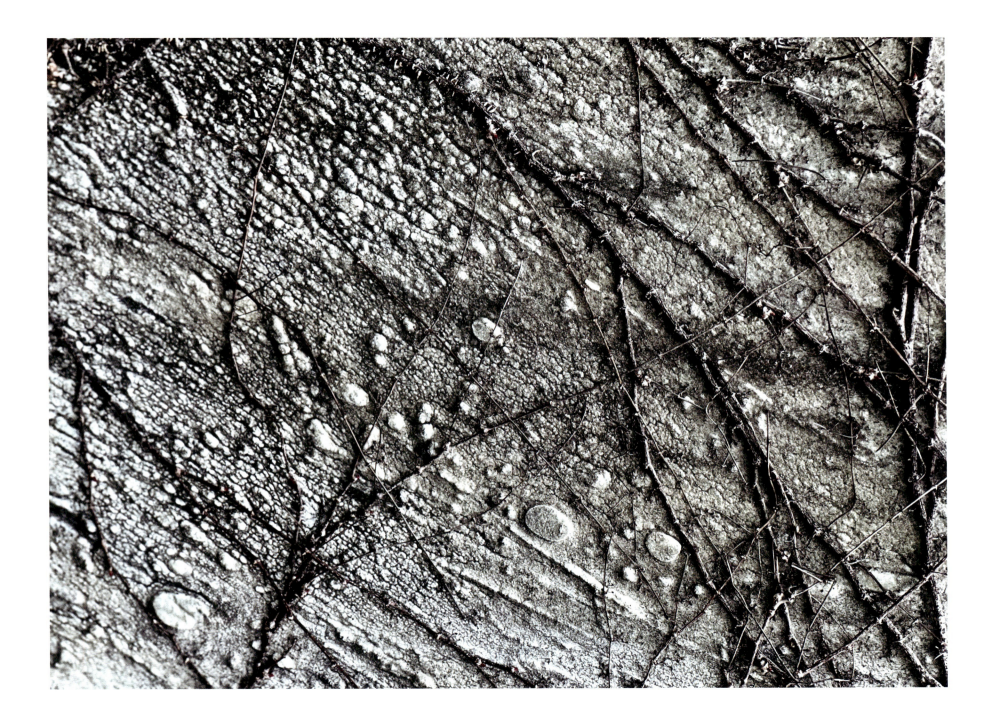

Introduction
by Cole Swensen

One of the first things Bethany Jacobson said in a recent interview was that, initially, she went to the cemetery to get lost—thus casting loss as an end in itself—with the sense that loss is also a beyond—beyond this earth and this life that we know—a recognition of loss as liberation.

And through loss, the cemetery allows us the freedom of the bodiless, and though a statue on a tomb tries to give the dead a new body, to anchor it down, and us along with it, it never quite works—the dead still go off in their ephemerality. And these photographs, too, release rather than recapture that ineffable whatever-it-is that is always trying to flee us, and that we're always hoping will get away so that we can be pulled along in its wake.

She also mentions oasis—the cemetery as an oasis in the urban chaos—which raises the question of the relation between oasis and the dead and suggests death as an oasis in itself. Which further suggests a triangle: loss-oasis-utopia—with utopia as no-place—as we see death as—reconnecting to that meaning while yet retaining the more popular idealistic sense—and thus connecting that idealism also to loss, a leaf falling upward instead of to earth.

And death does give us pause. We stop. We look up. And see that we are nowhere that we know.

Perhaps it's odd regarding a cemetery—or perhaps it's logical—that Jacobson's photographs of Green-Wood are engaged, above all, with release. They may begin in statuary, but they overflow that focus to take us to all that surrounds them, all that levitates them, from the grass to the trees to the clouds that are all part of their completion. They make us acutely aware that no work of art exists apart from its context—the thriving system of plants and waters, of birds lacing the sky together in pieces, parrots streaking green against the green of the trees, and the under-feather of something smaller that drifts down to land on the page on which you're writing, its white getting lost in that of the paper or sinking below its surface.

And the hawk, its arrow eye, the owl piercing night, and all the rodents, small mammals, reptiles, and insects that thrive here—the irony that this "land of the dead" is one of the few places for miles around that non-human beings can live.

And all the "non-living" elements in the system, from the gravel paths to the ornamental ponds, to the wind, whether raging or wafting—all that, in looking back, casts a net to catch the drifting world.

Juxtaposition is always an ignition: the grey of the stone, its low and constant hum, face to face with the tree bright with its small flames in flower, always headed upward—sound against sight, matte against shine, time rising against time refusing to move—contradiction sets something alight.

In confronting monumentality, these photographs multiply it: juxtaposed to statuary commemorating the dead are trees exalting the very fact of living. Which are the more monumental doesn't matter—what matters is that they face each other across a gracious silence and neither gives an inch.

Jacobson often chooses statues of women—solitary female figures that in their great numbers can't help but create an echo between "solitary" and "solidarity"—suggesting cemeteries as sites of radically inclusive camaraderie. The solitude that they occasion is so extreme that it, too, overflows into a solidarity of the living with the dead, of the mineral with the vegetal, with solidarity and solitude multiplying each other, as if even in isolation, we participate edgelessly in the fluid world.

And the worn and wearing-away bodies of stone echo the constant dissolution of the individual into the collective over ages.

We try to make monuments. We take the most solid thing we know—stone—and turn it toward, turn it around, make it face something perhaps only it can see. Perhaps in creating the blind eyes of a statue, we create a sight that we cannot access but can nonetheless sense. Perhaps funerary monuments are a way we've created of seeing beyond death—and they do.

We try to make monuments—and we place them in intentional arrangements—and then along comes a tree.

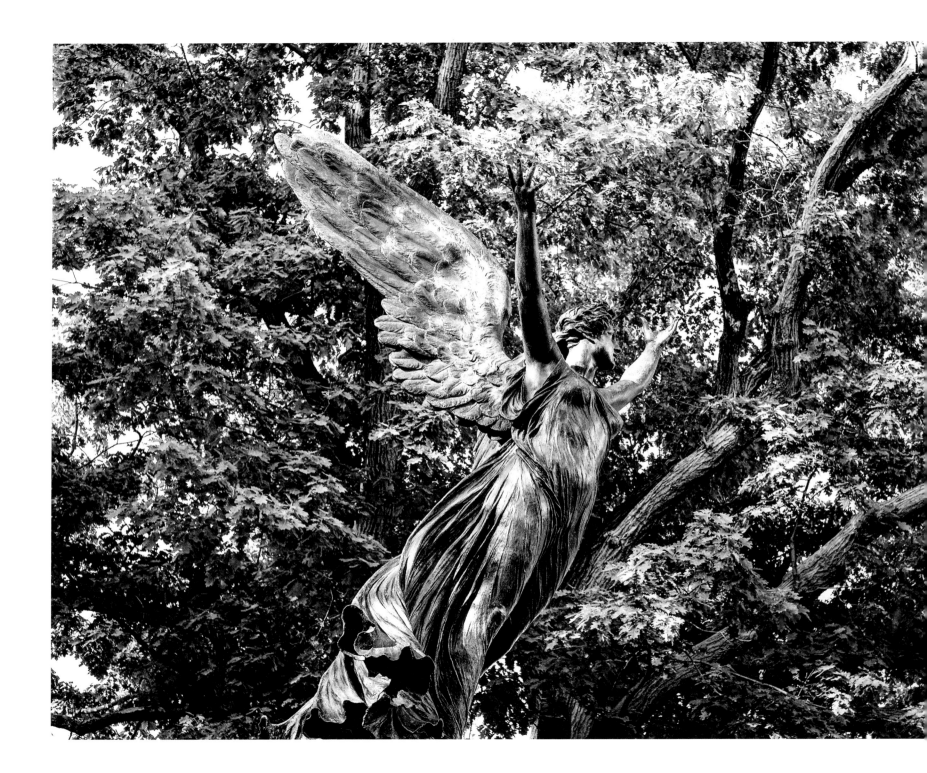

Arms of an angel thrown up in exaltation, paralleled by the limbs of an oak just living another calm day in the sun. If a monument tries to stop time, its placement next to a great tree gives the lie.

The hand rises—Abhaya—and all fear stops—dead in its tracks. There can be no fear in a cemetery, as all our fears boil down sooner or later to a fear of death, which is impossible here in the midst of its peace. And the hand rises, empty and friendly, on the statue of Minerva, goddess of wisdom, justice, and law, goddess of the owl, dividing the dark and escorting all escape.

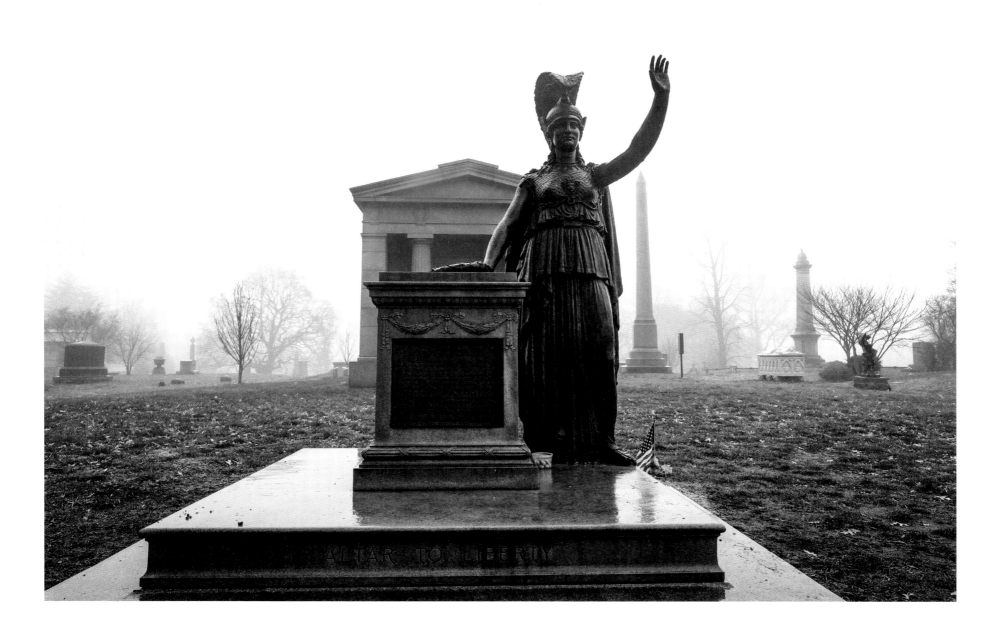

There is above all green—and as above, is all that's seen—or is it that the light, filtered through this thriving life—does green mean life?—or is it just the love of it? A late sun through leaf, and late trees touch us so deeply that a clearing occurs.

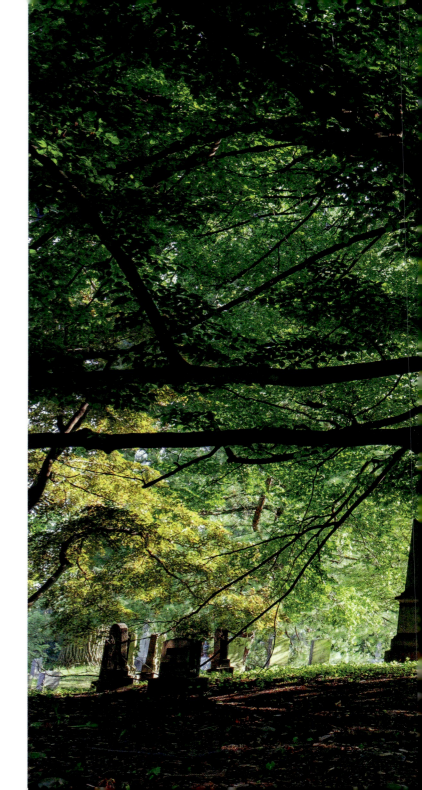

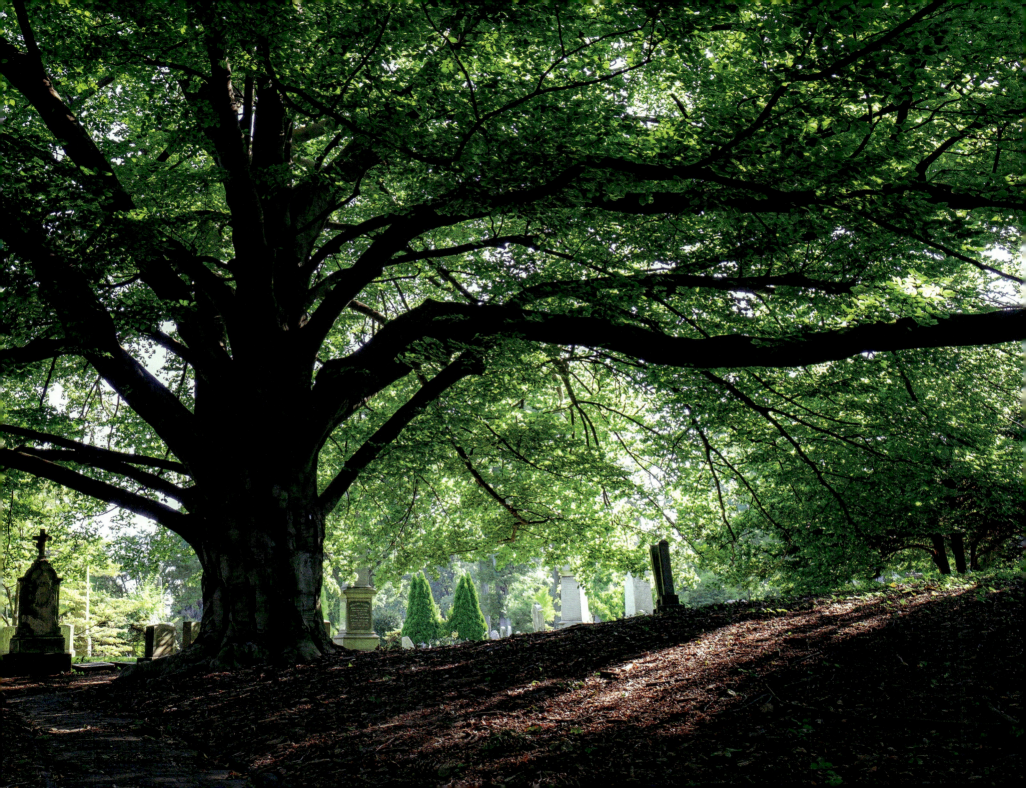

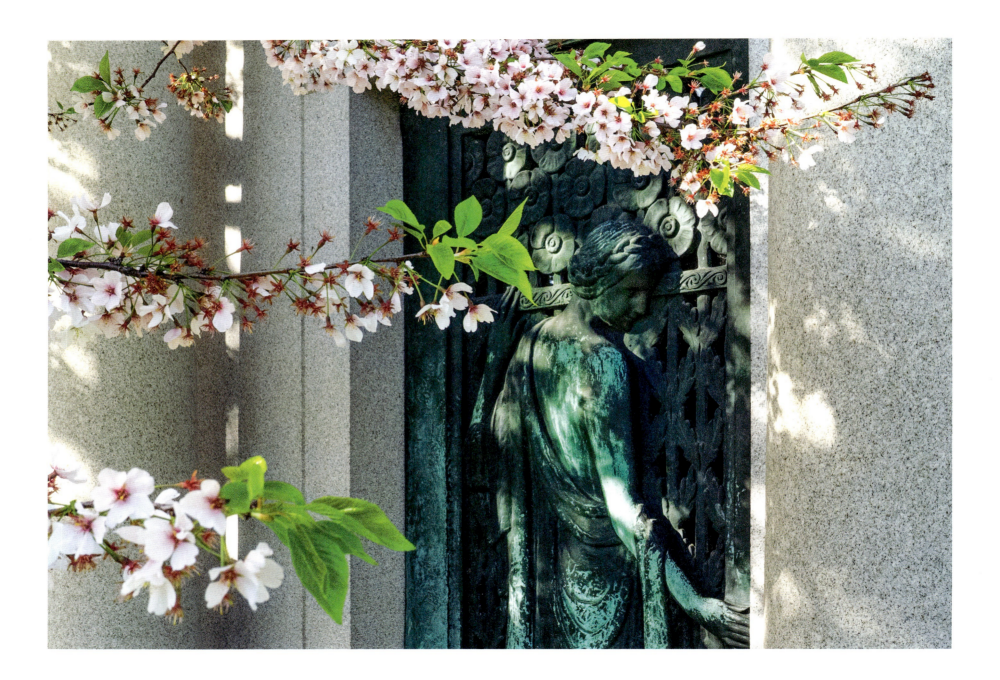

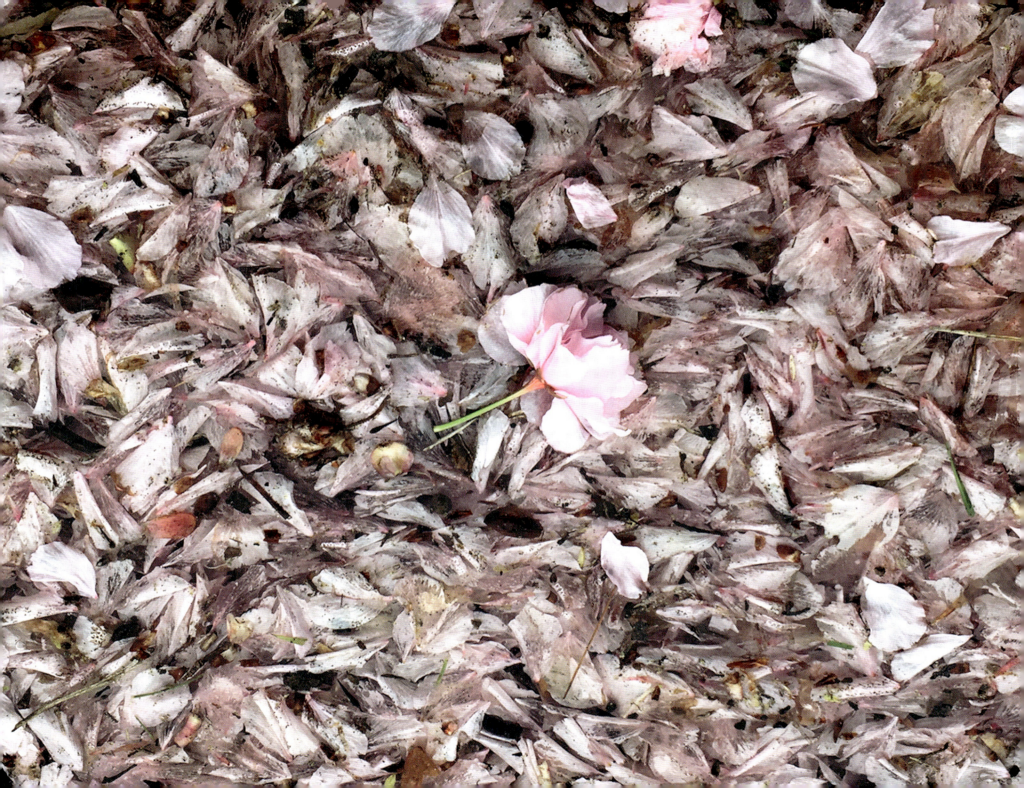

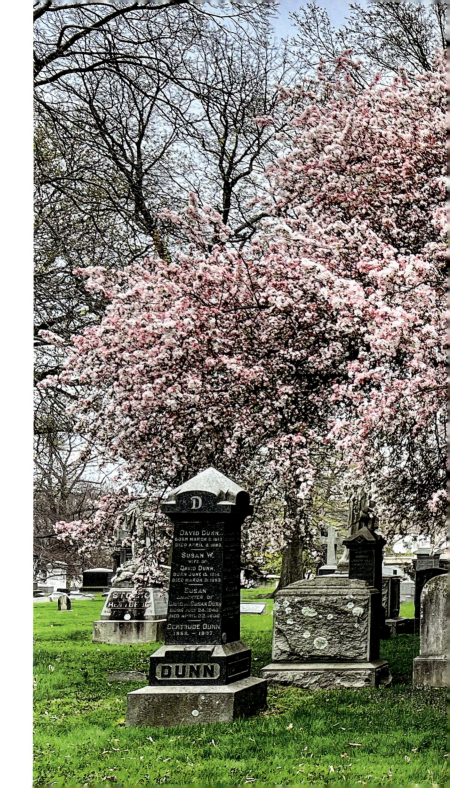

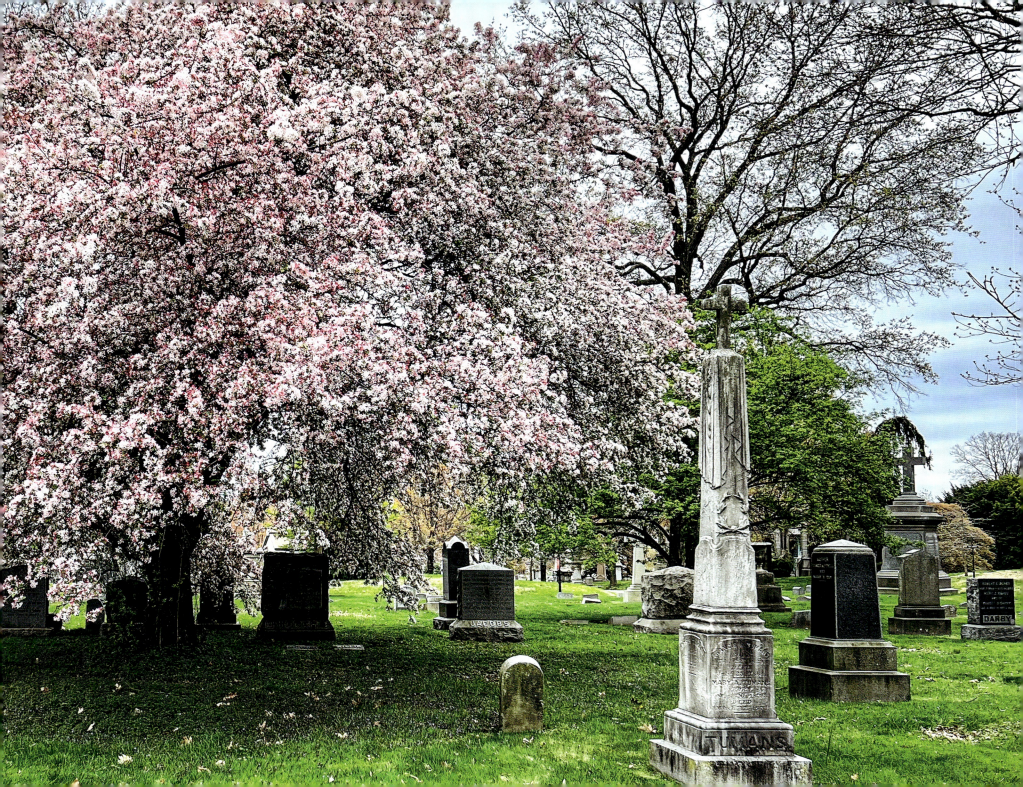

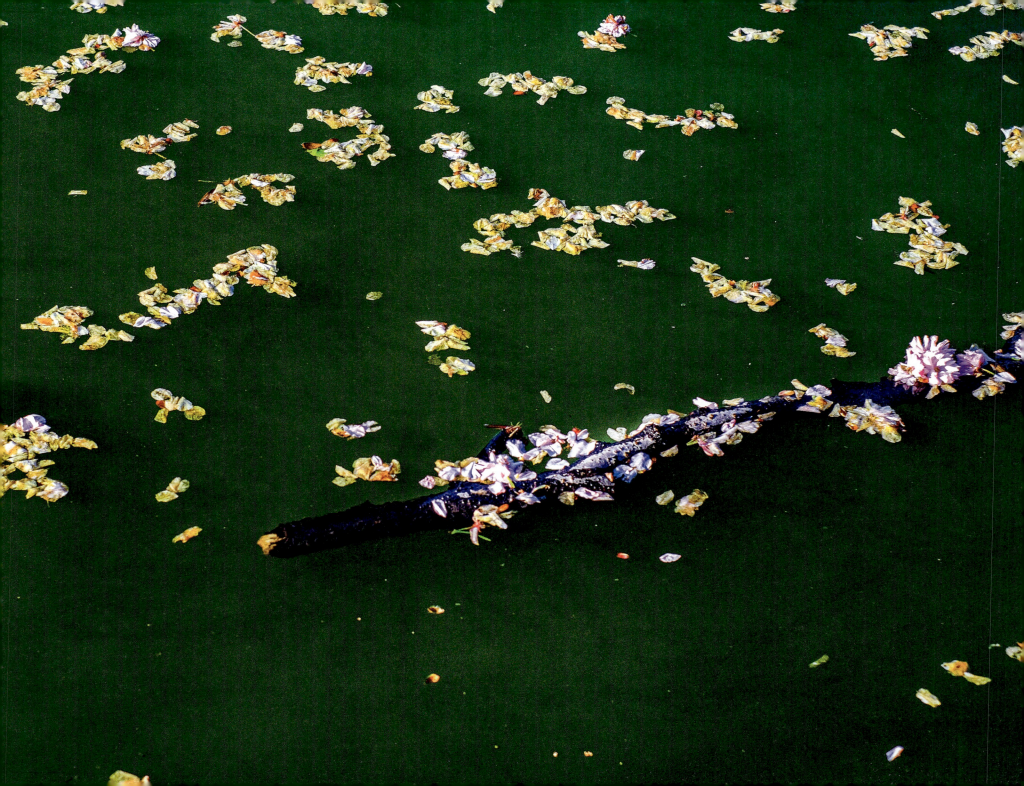

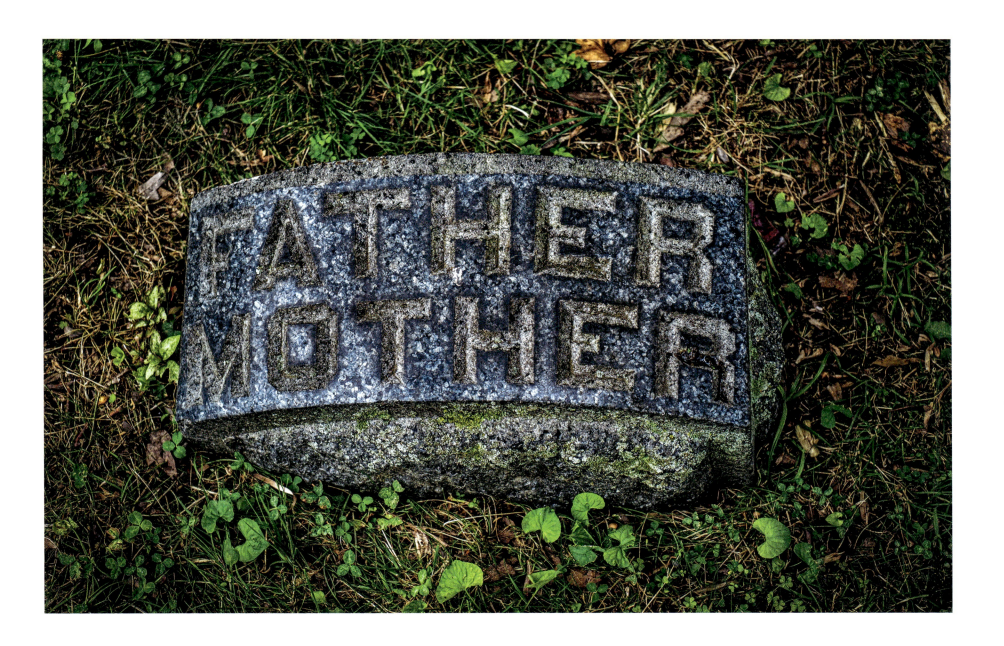

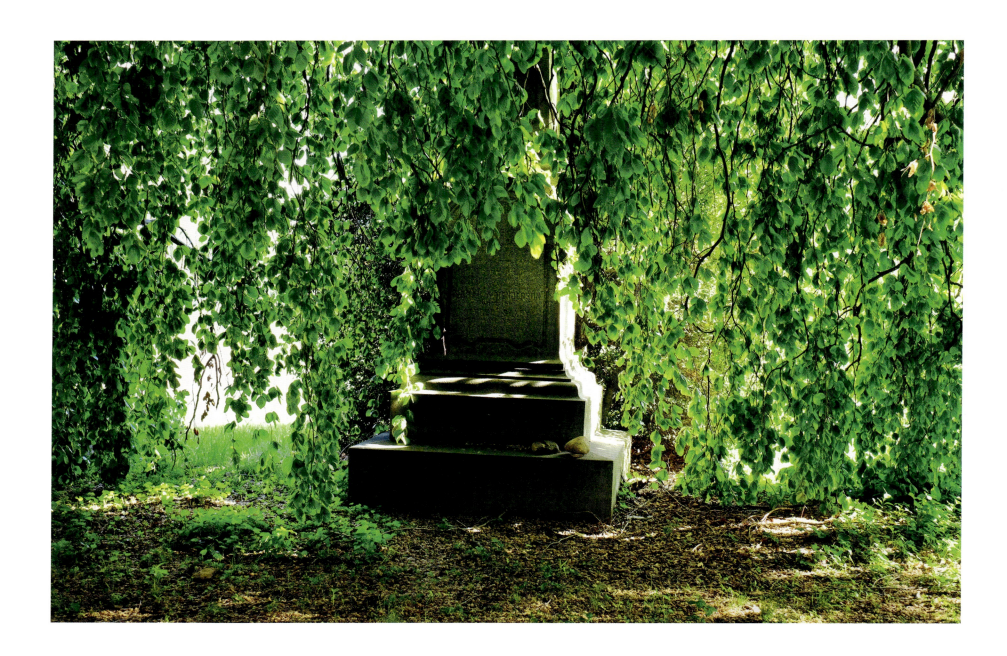

Some trees weep, they say, but then they don't. They bow down low, like a veil before the grave. To remind us that the grave is a veil all its own—and as it's stone, it will not be lifted. While the veil that is life is continually swept aside—here it's by the wind, though elsewhere, a passing bus, a crying child, and there it is, suddenly conjugated into time.

So rarely a living person, upright, perhaps a little defiant—how can the living not feel a bit resistant in such a place—and their thriving perhaps causing offence.

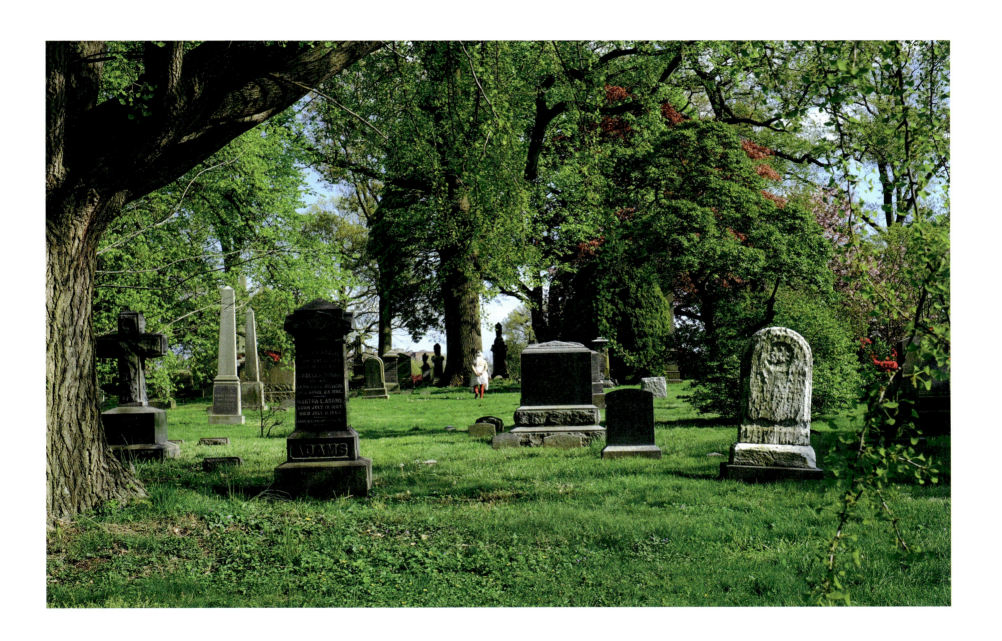

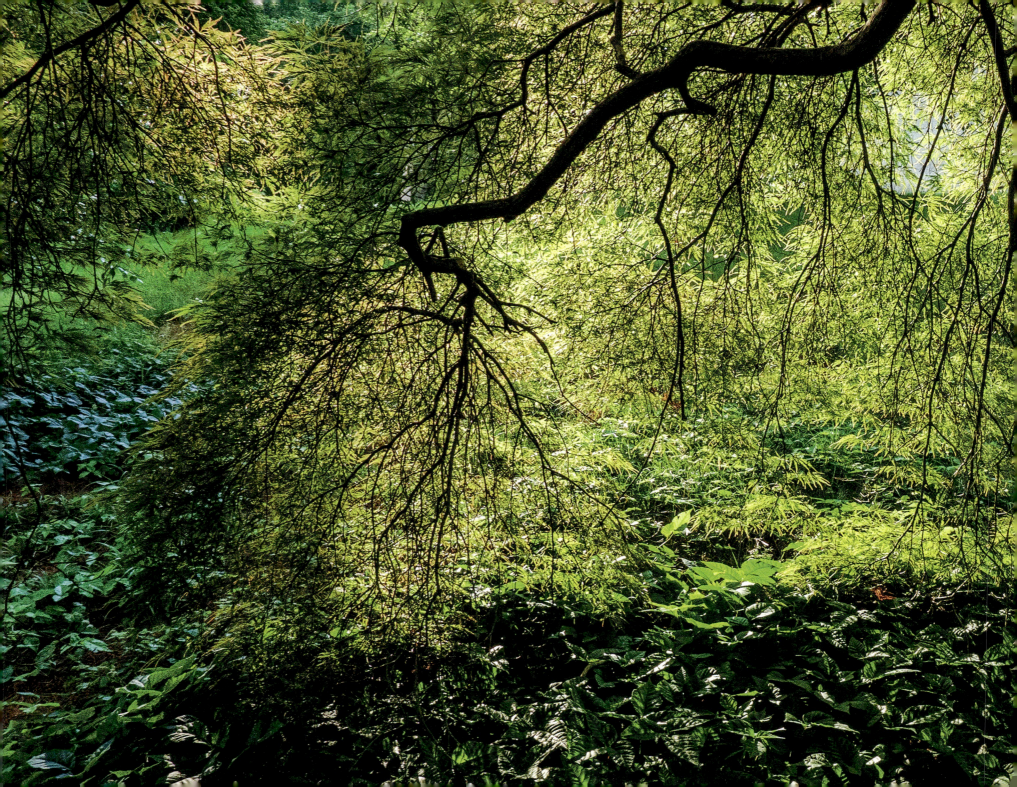

Of all of the greens—collected, flaunted, counted in sleep without number—they multiply, and when we return the next day, there they are, all over the sky, calling themselves trees because greens must be contained, or must seem to be.

The catalogue continues—a green leaning toward blue-grey: enter blue Atlas cedar to demonstrate the multiplication of life, as if every new green were an additional dimension, and that particular shade, the only way it can be captured.

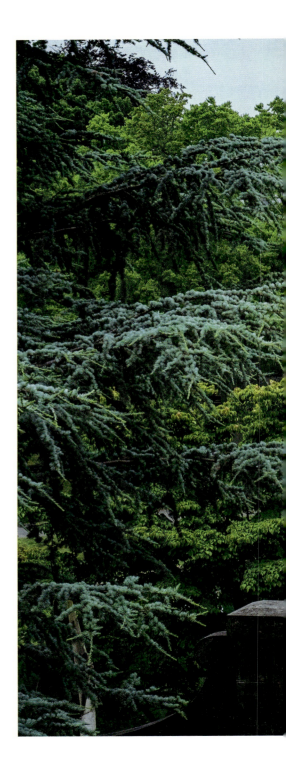

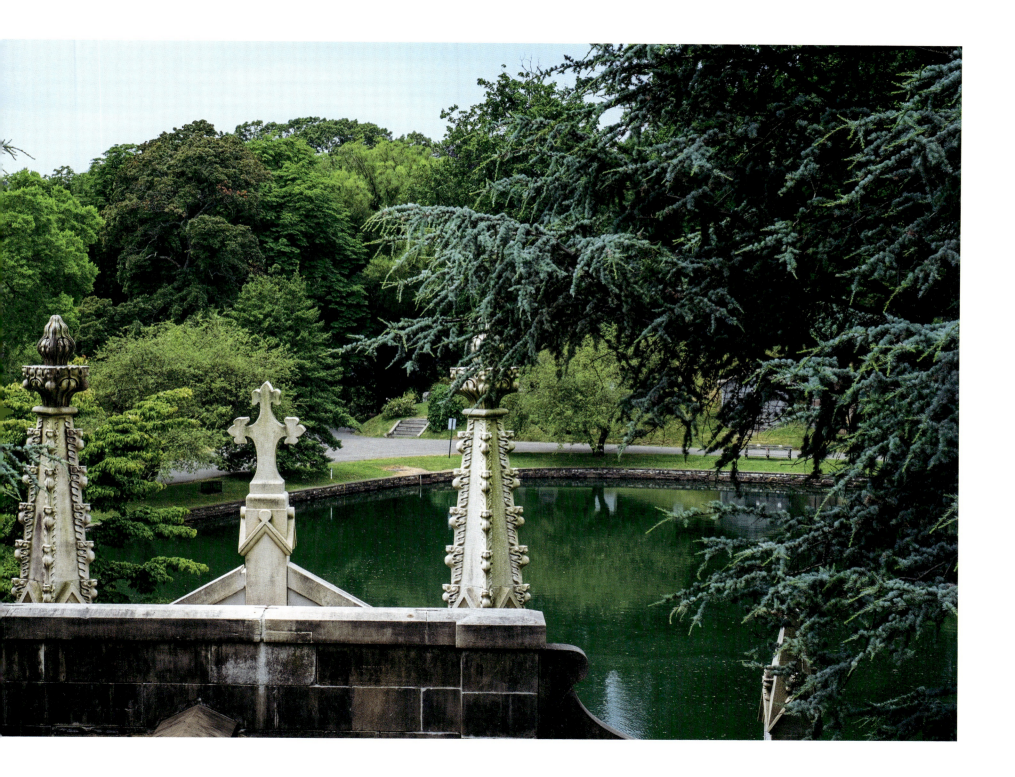

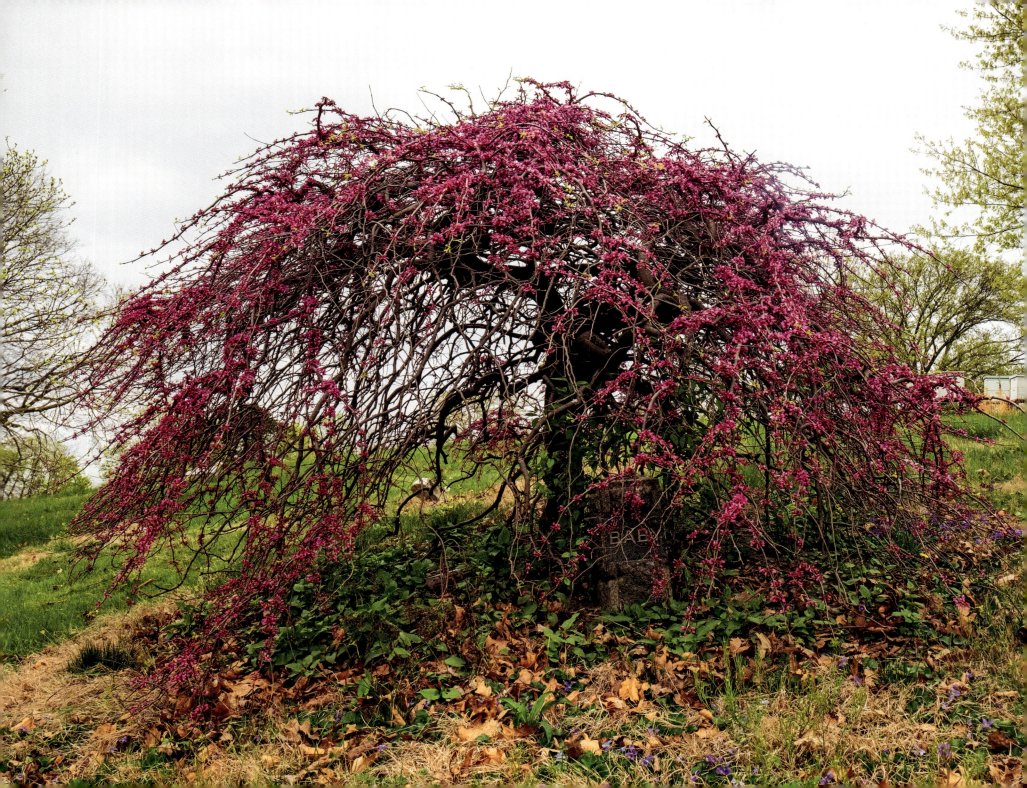

How the monument of flower over-towers—how now itself almost over-powers—and the living suffocate the dead with such a delicate scent.

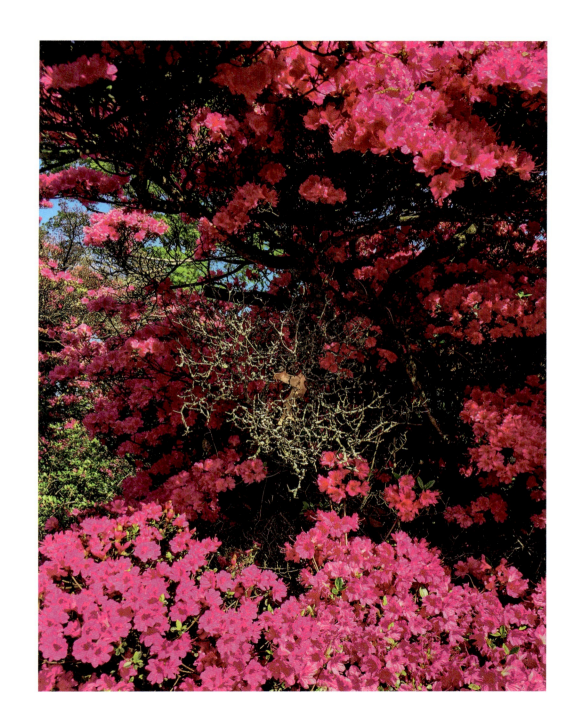

The riot of flower in flagrant defiance—there's a touch of the audacious in the appearance of something so blatantly alive, here in decades of quiet. Another form of flight—and a cemetery is full of them—and this one, strewn across the sky, carrying it upward.

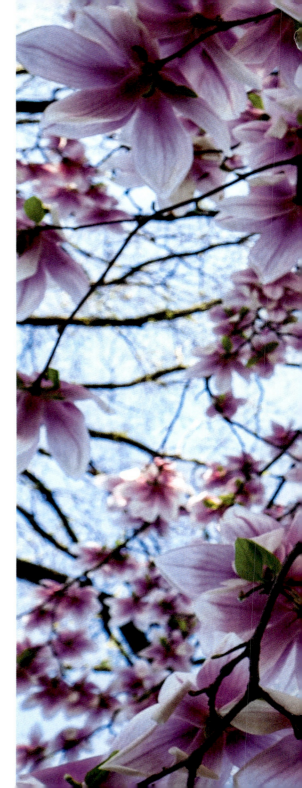

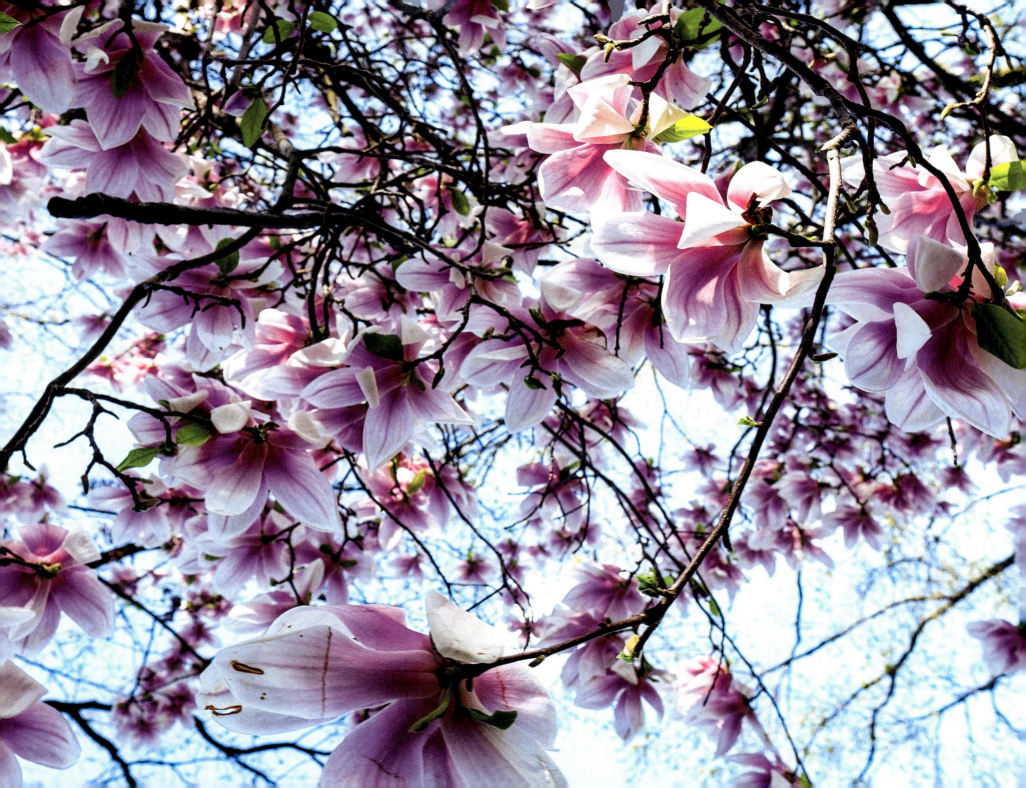

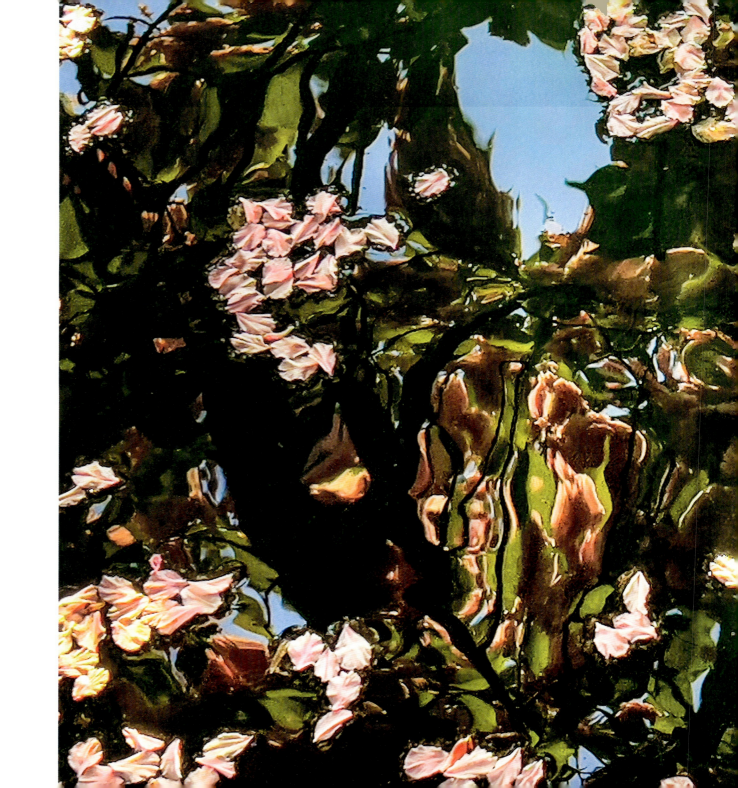

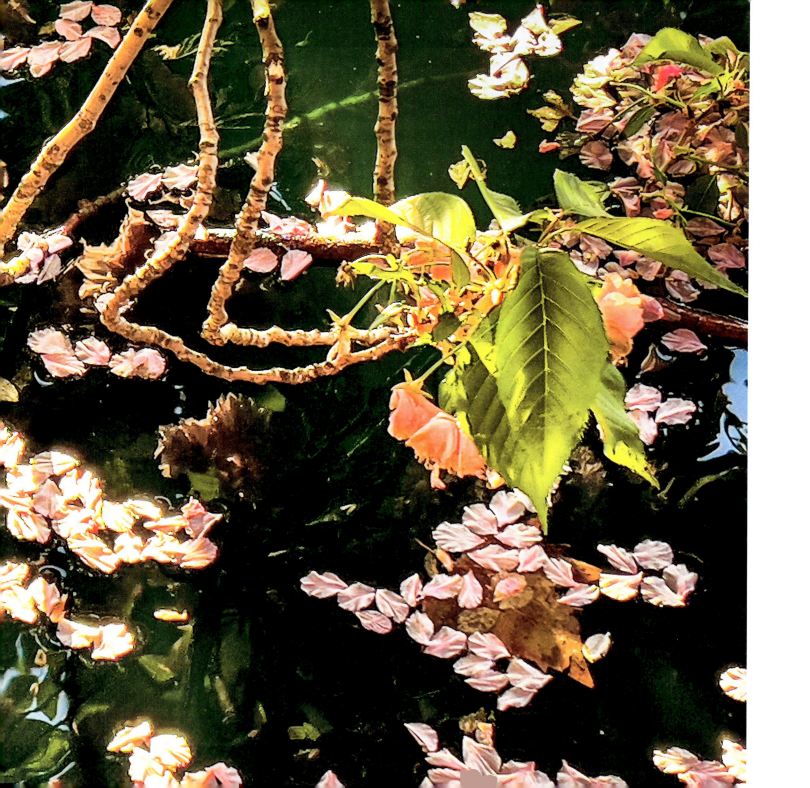

A tree in time is itself a wheeling, a reeling through sky—you look up at their great crowns and get dizzy—she looks up at their great crowns, and they burst into color—magenta, azalea, explosive, magnolia, flinging outward in a shower. Take cover.

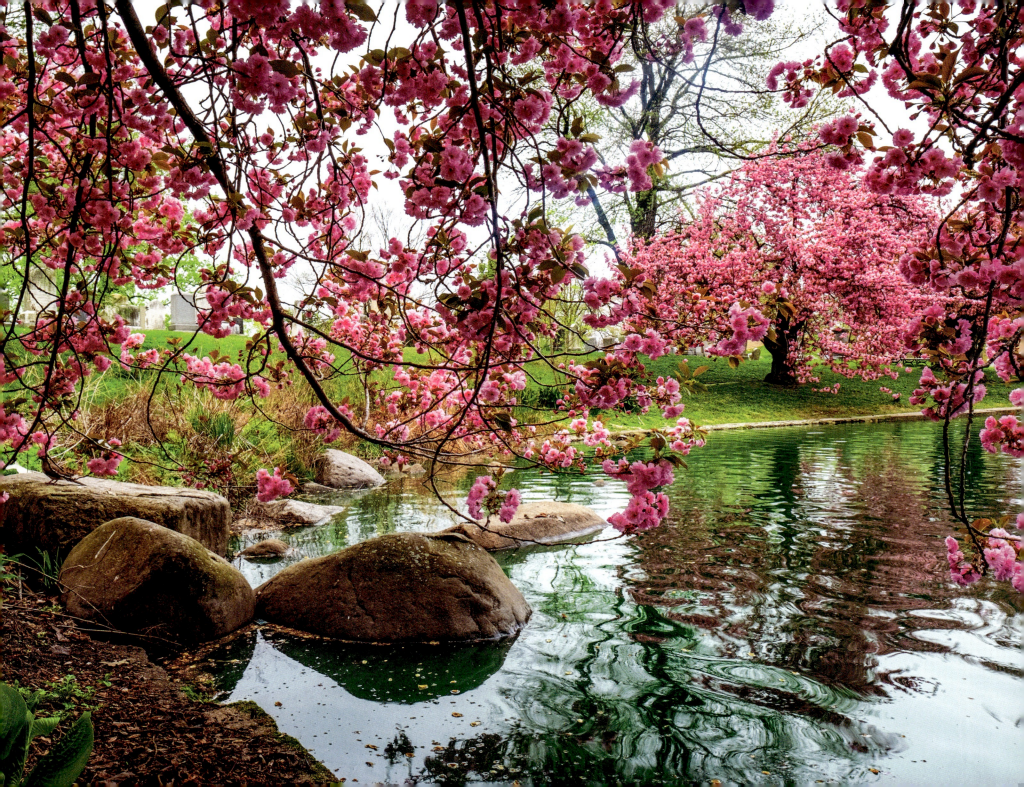

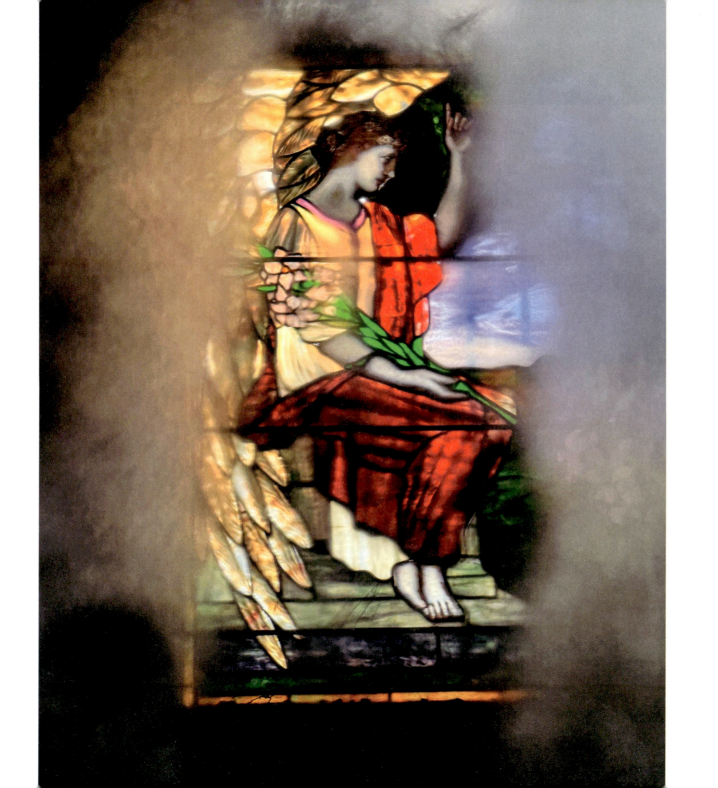

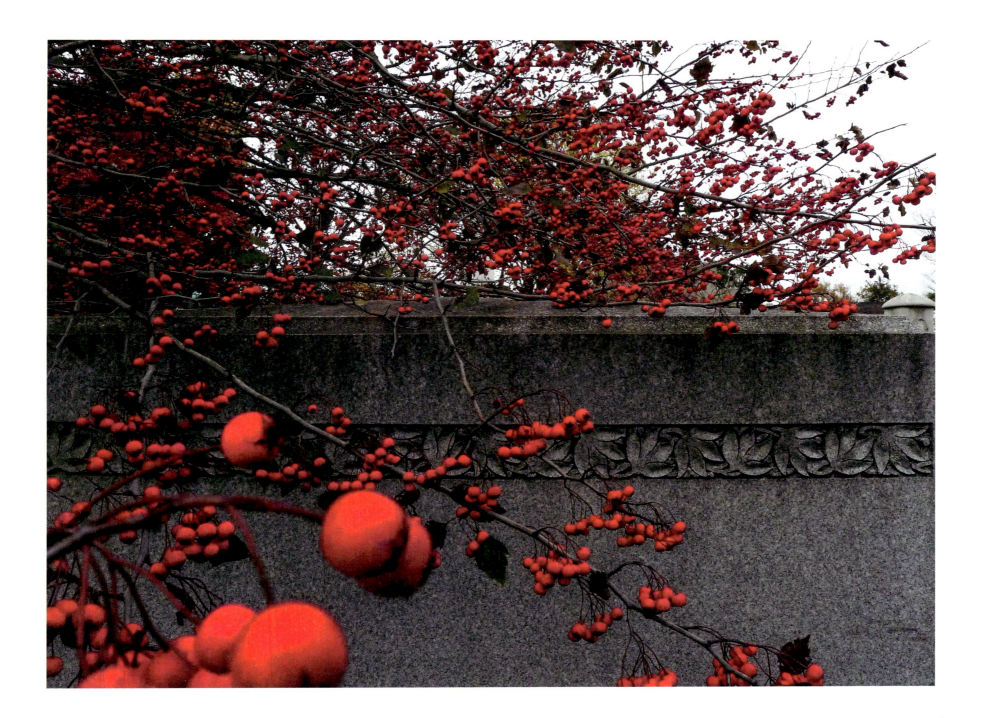

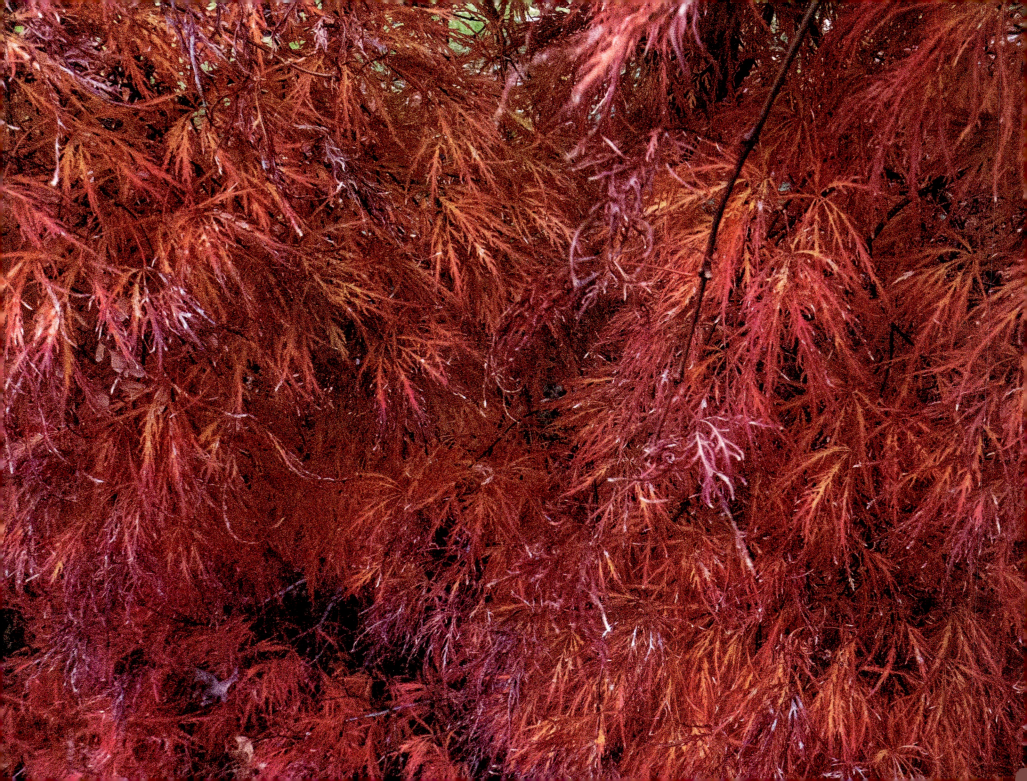

There's something of a red that comes—over-
ever, over-archer—a red that gives into radiant
others—the rubies, the cherries, the vermilions by
the million, and carmine divided by a thousand.
This is what it is to be a flower.

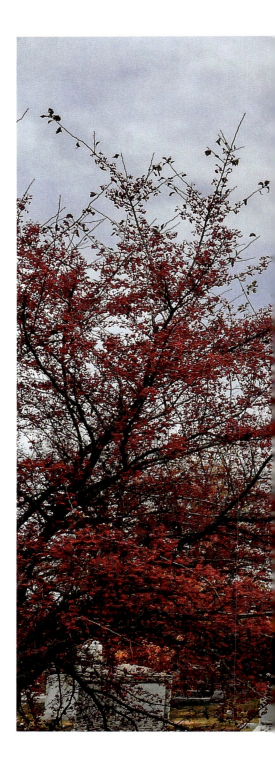

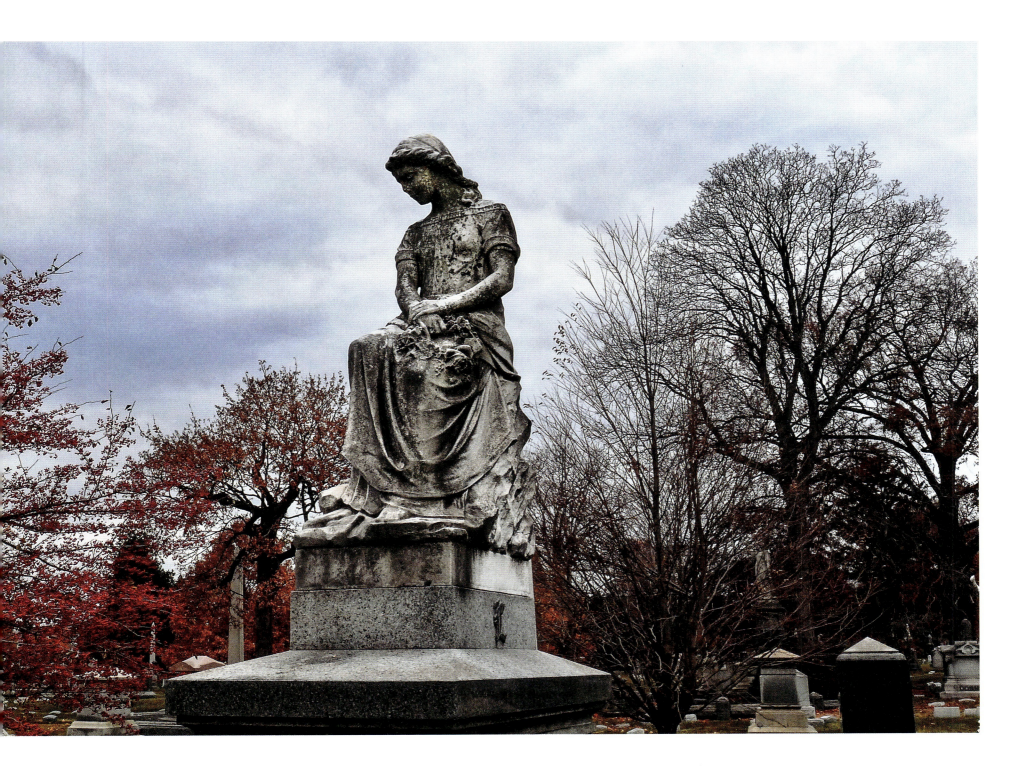

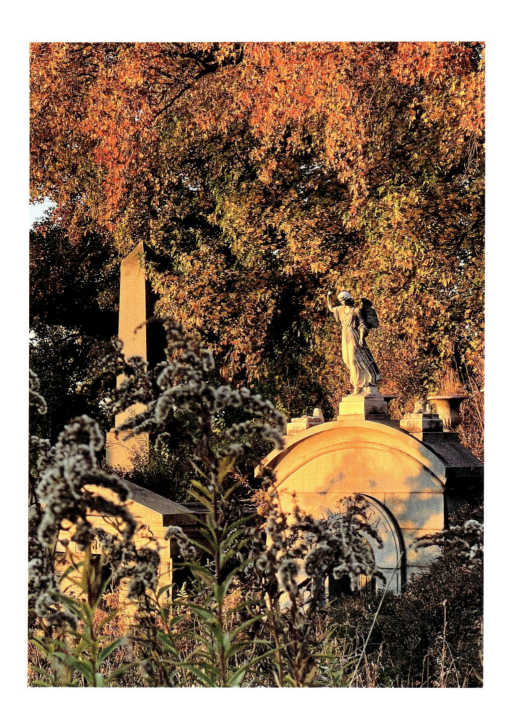

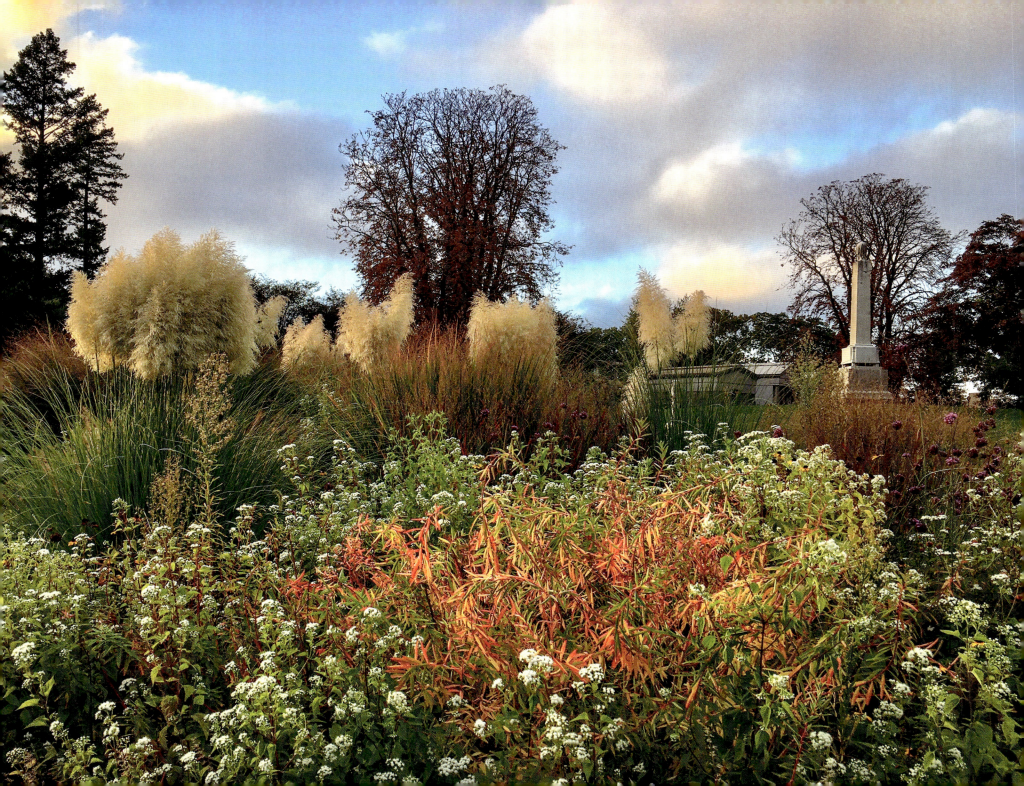

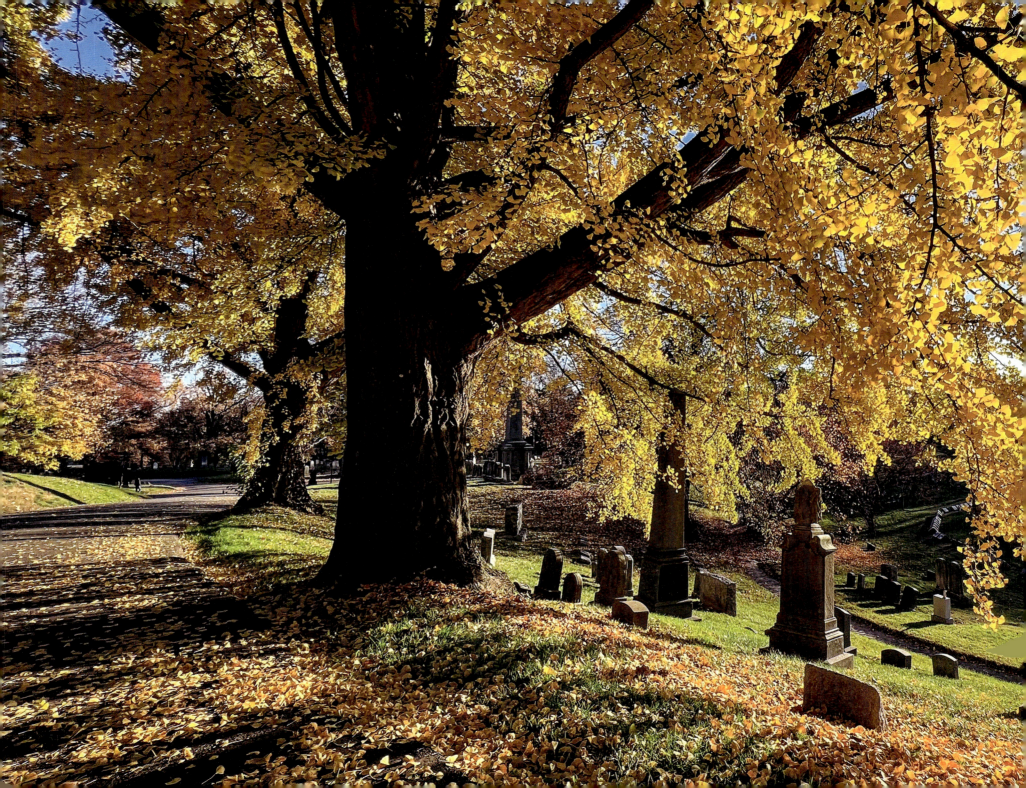

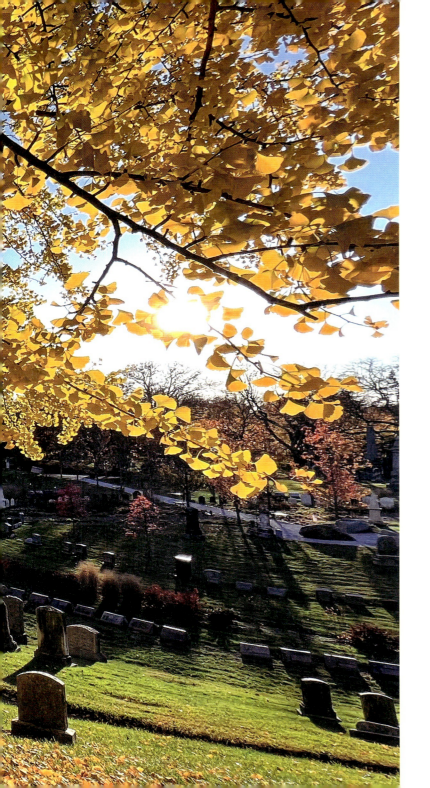

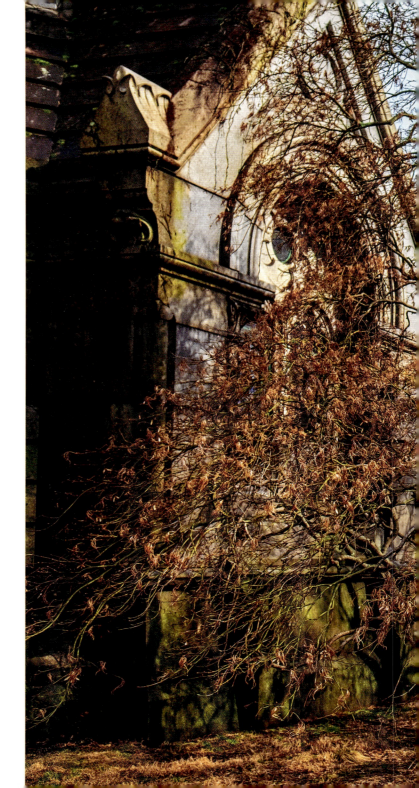

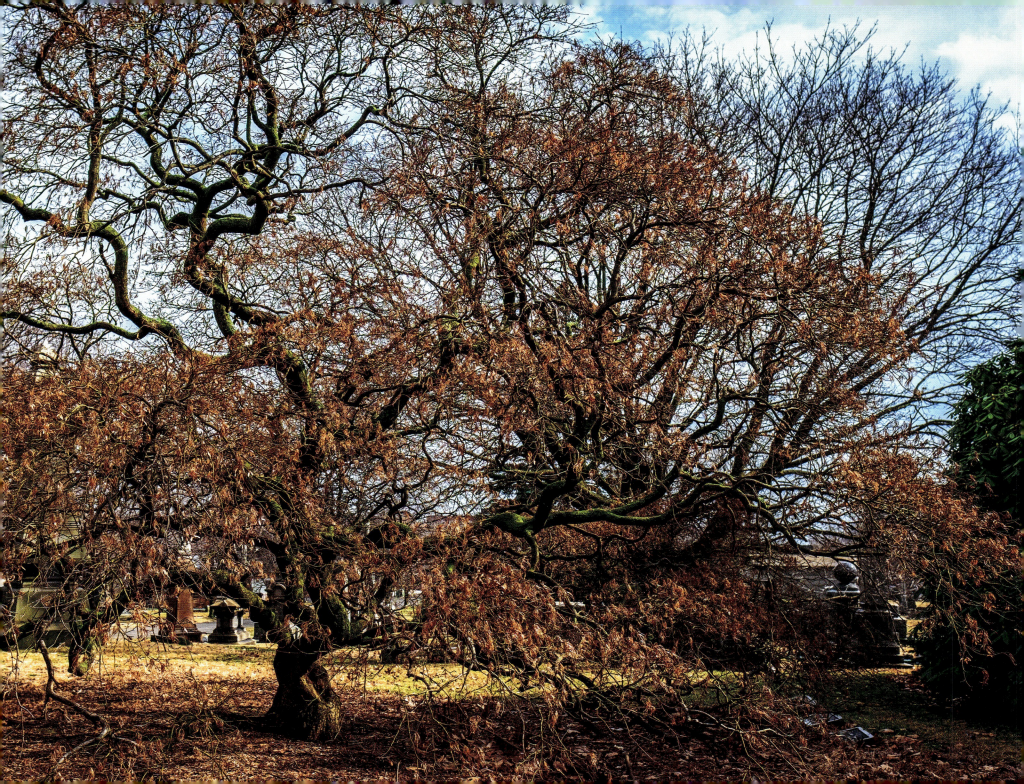

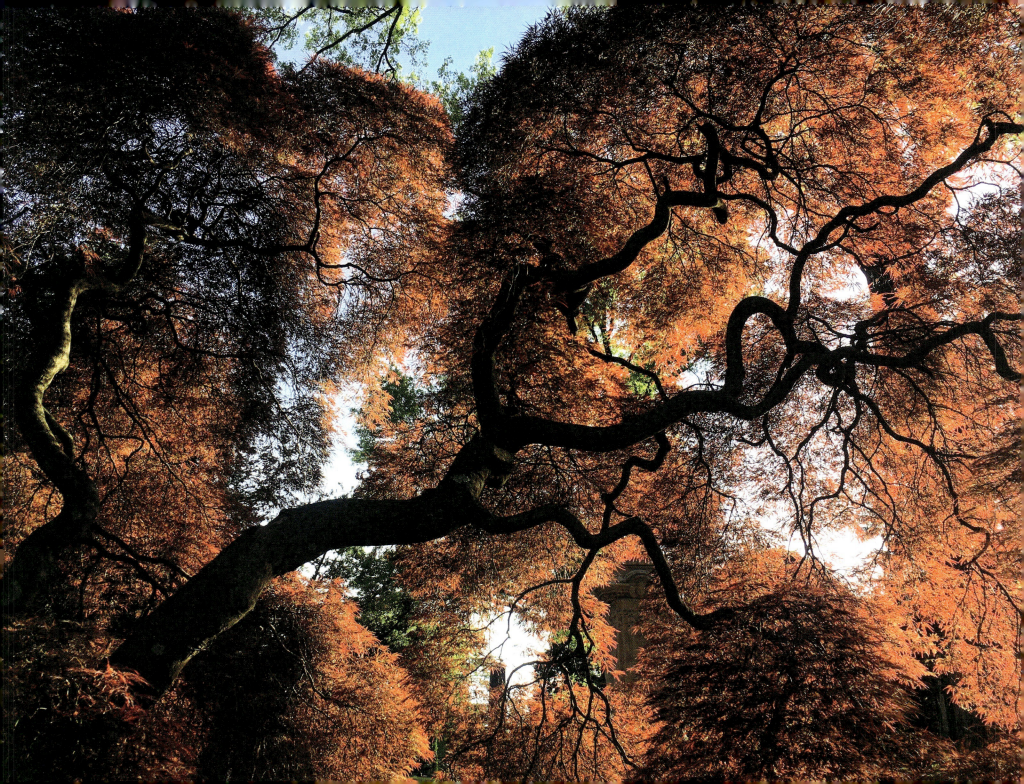

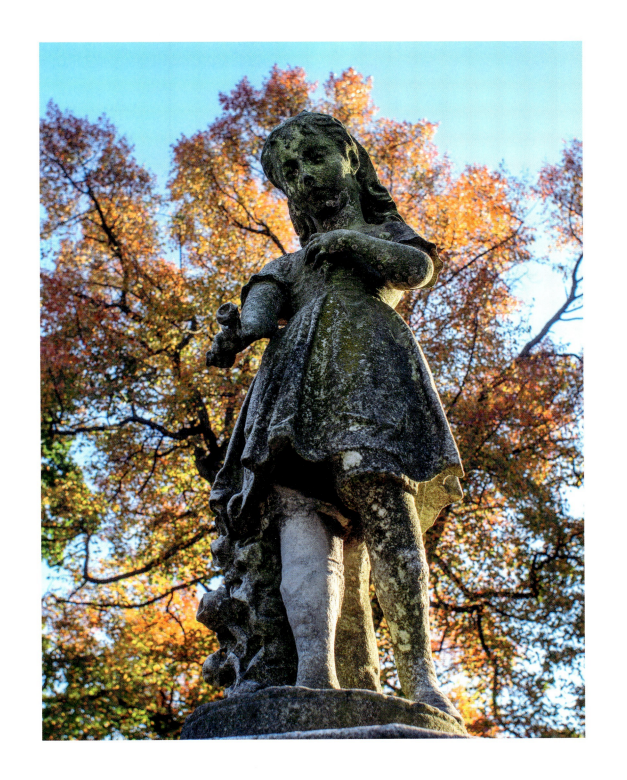

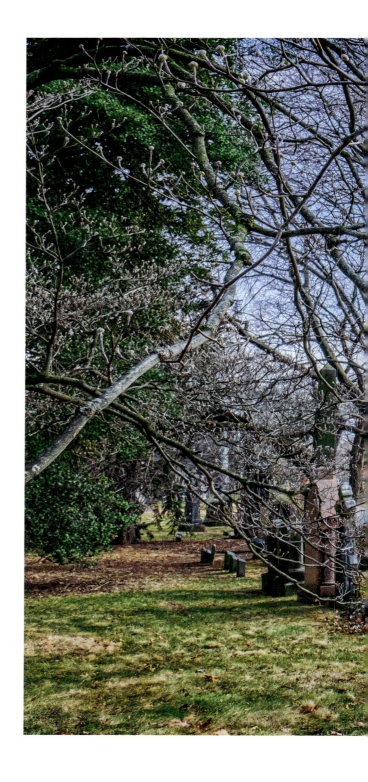

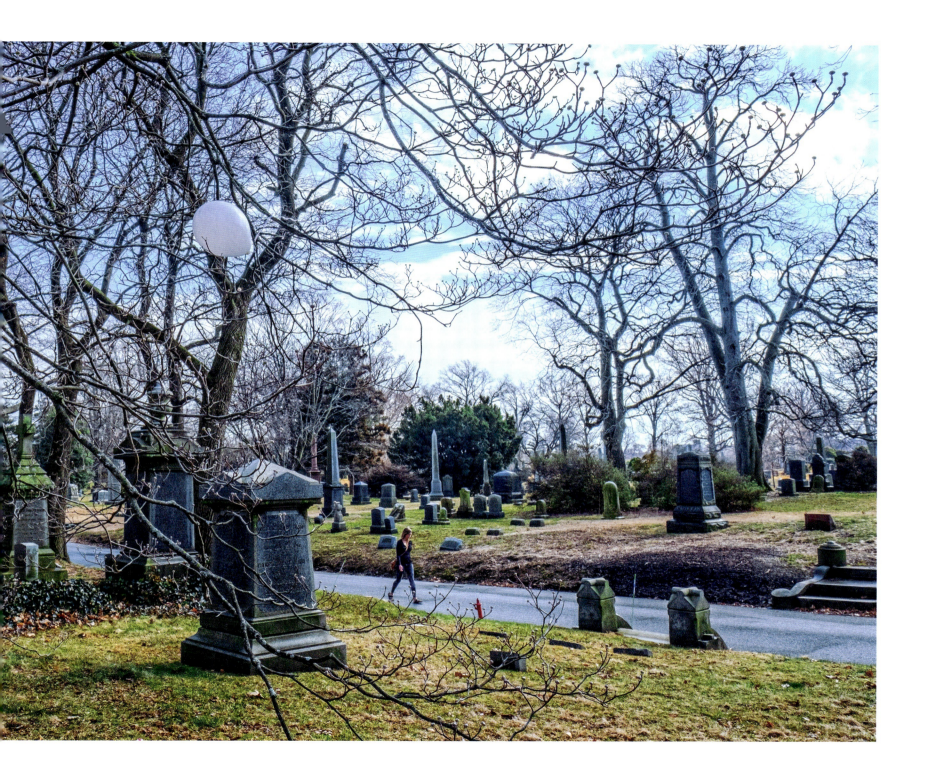

And then the explosion of color—suddenly it's over—it makes the sky higher, brighter, the vibrant life of light unencumbered.

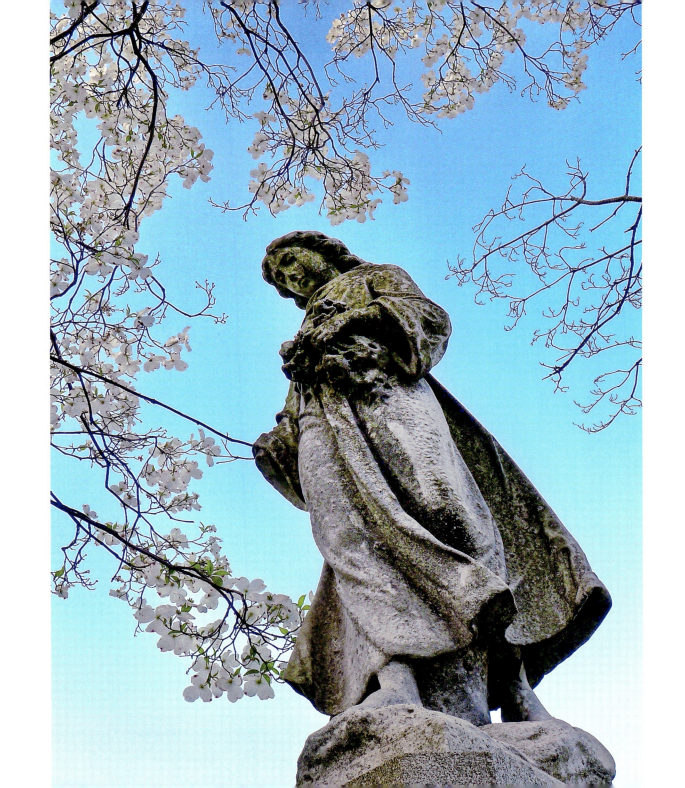

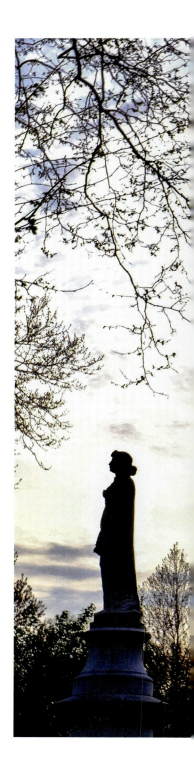

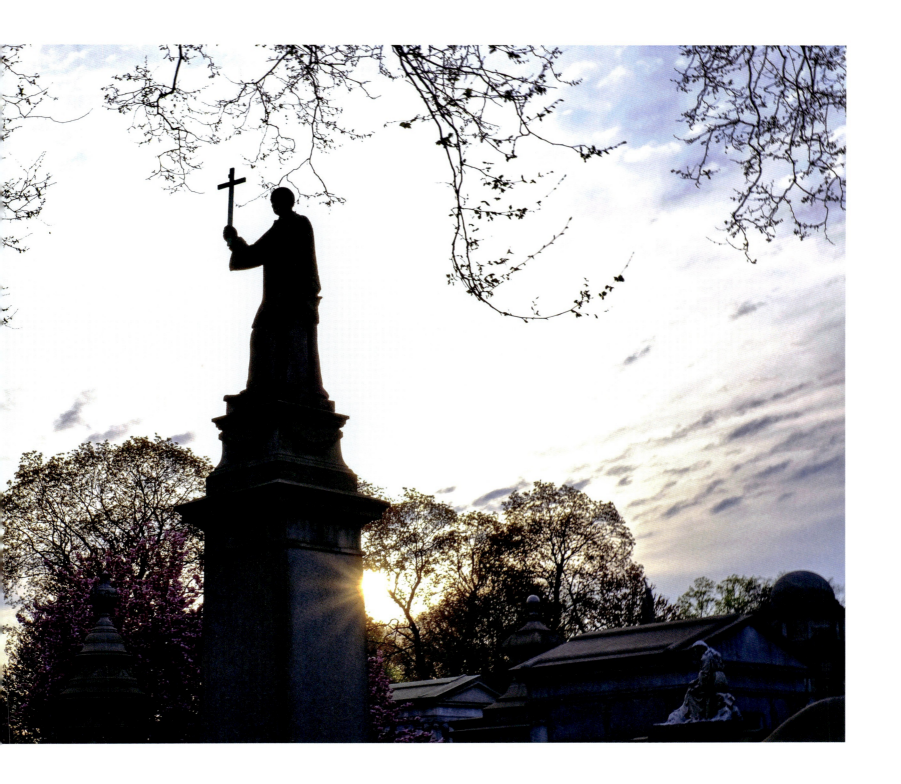

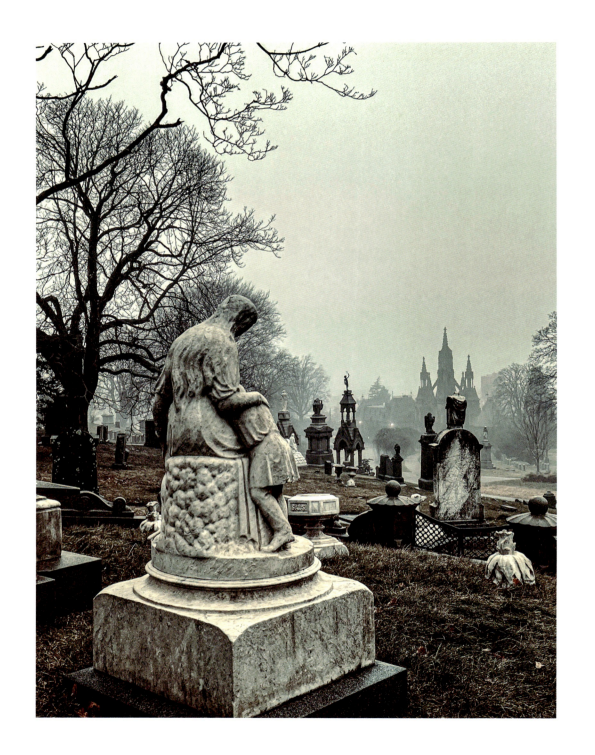

There's a ghost in almost everything—another form of flight—a softer fog lifting off as you walk into the cemetery one morning full of faces and their odd way of fading but not quite.

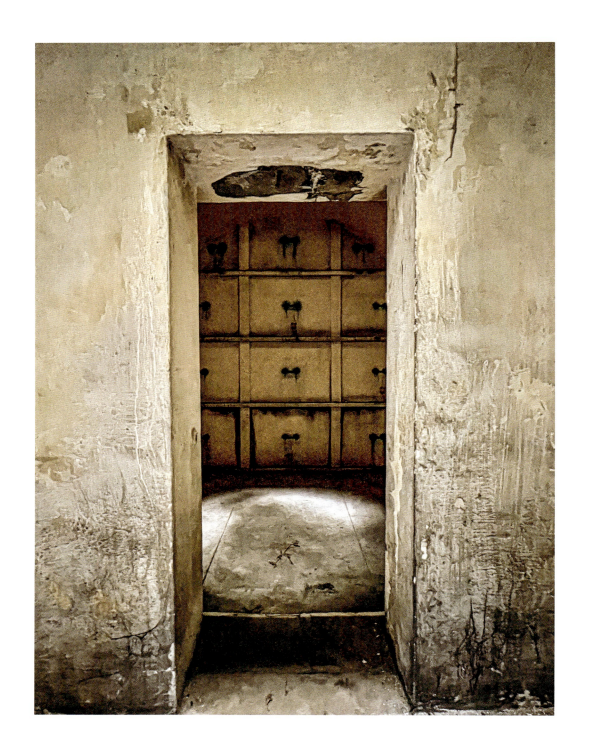

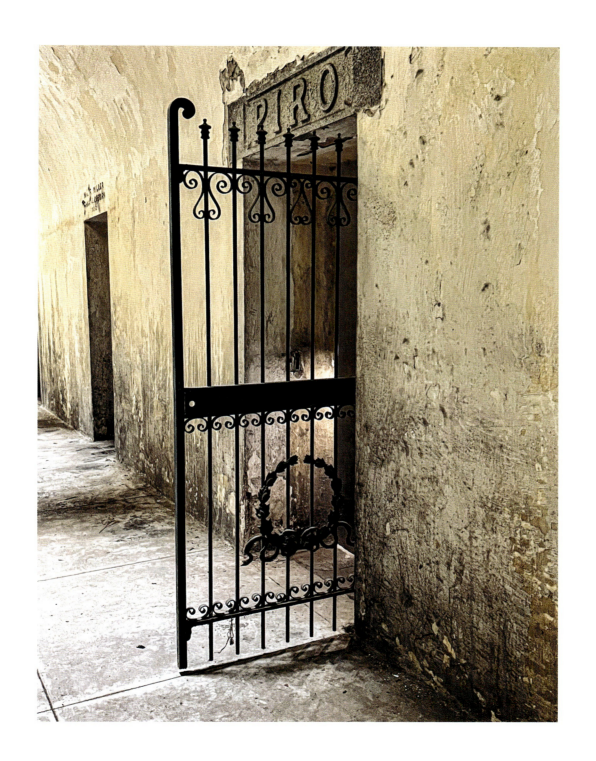

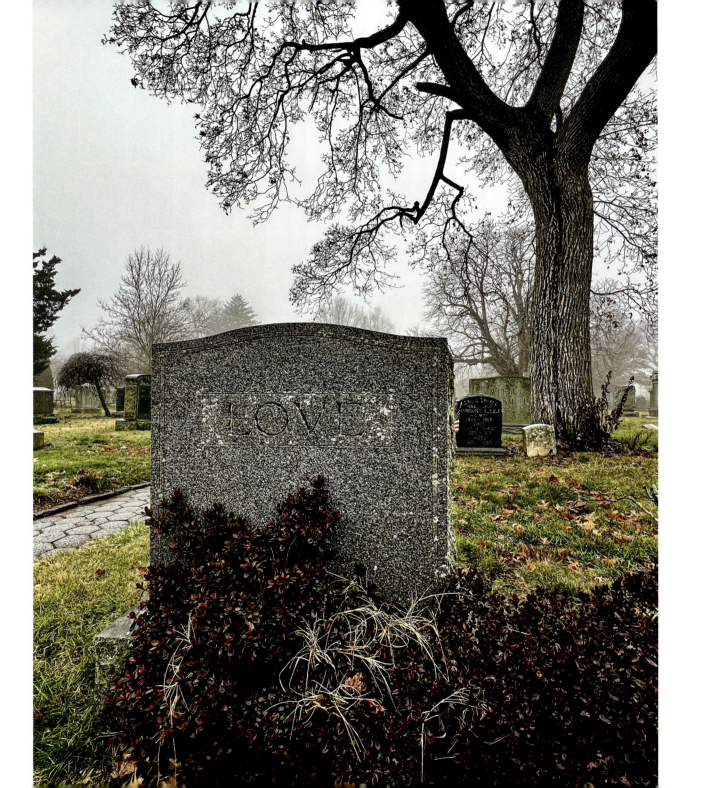

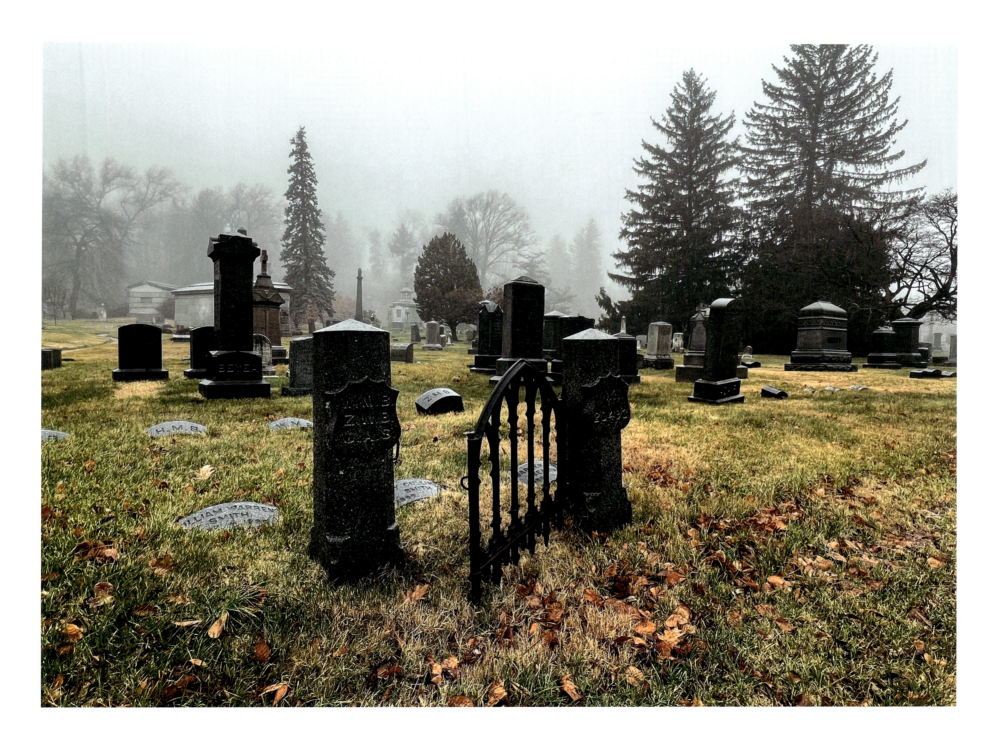

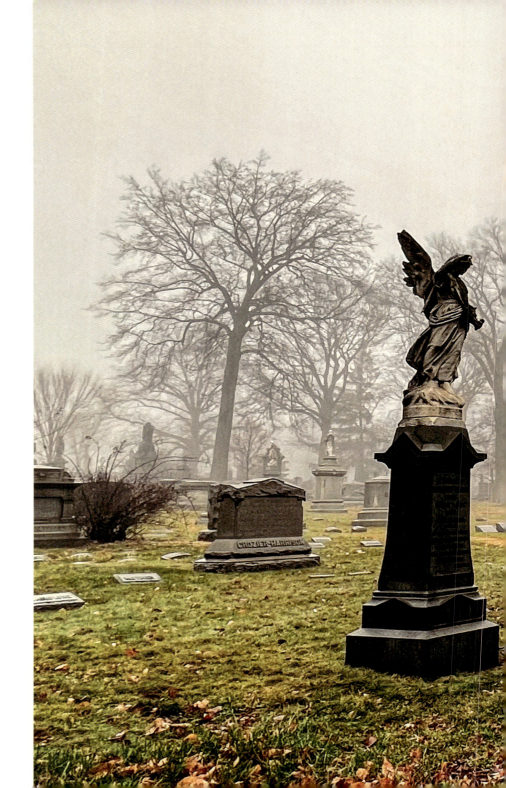

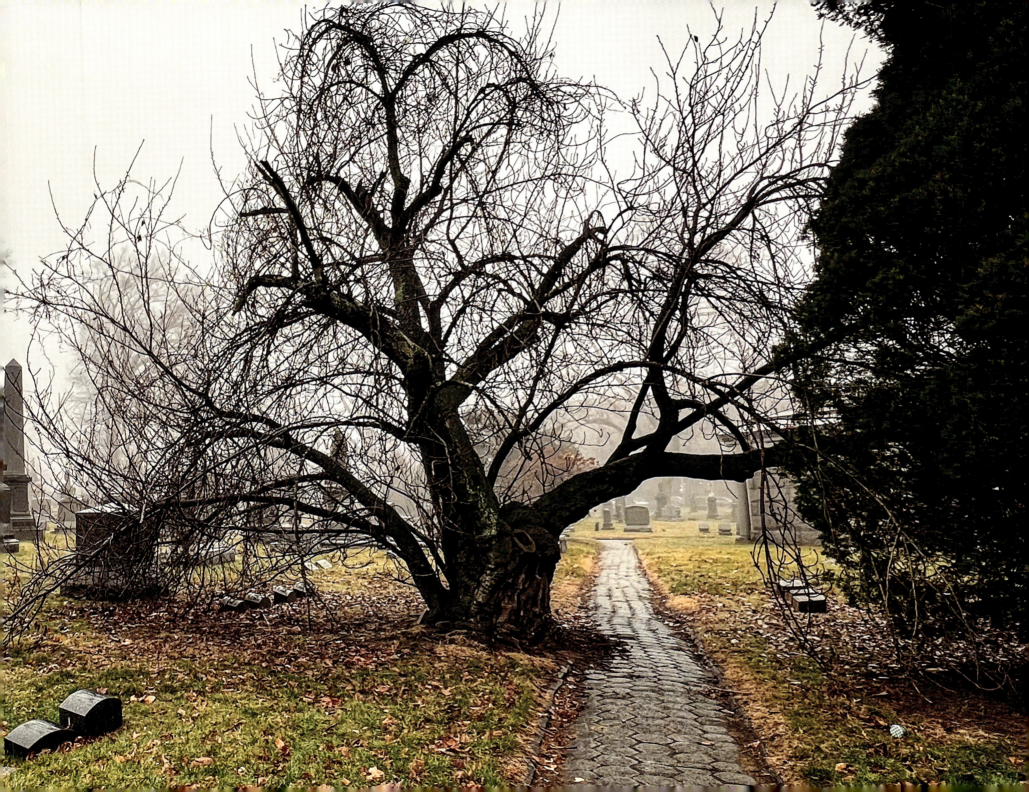

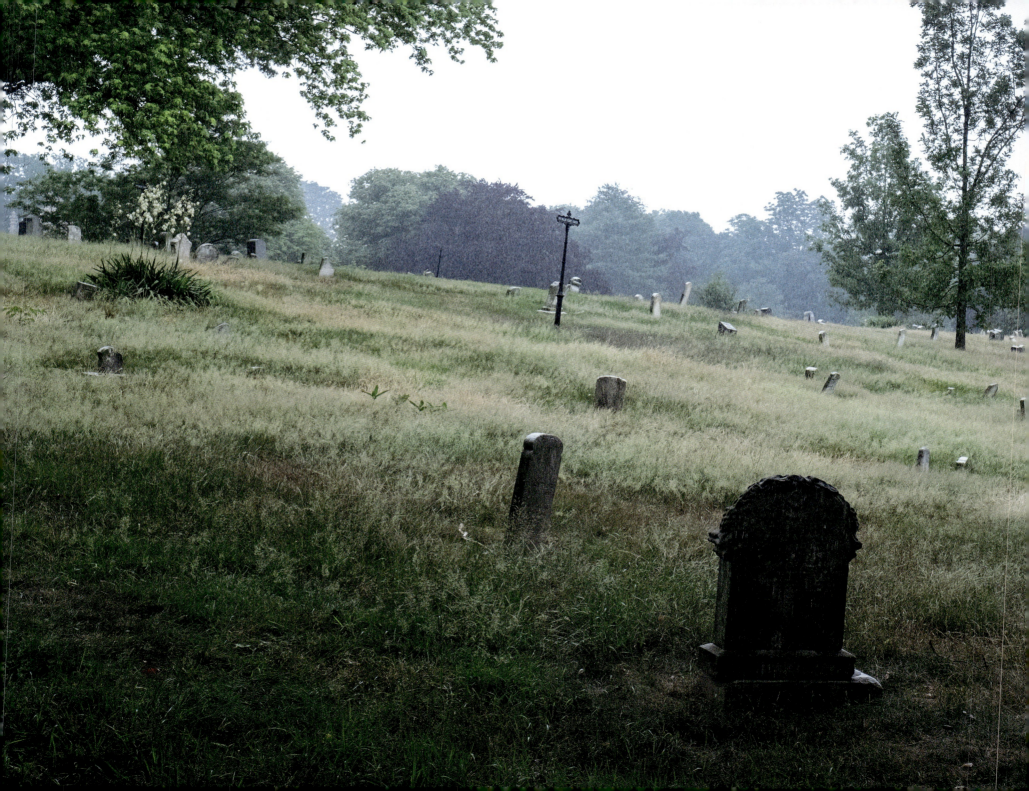

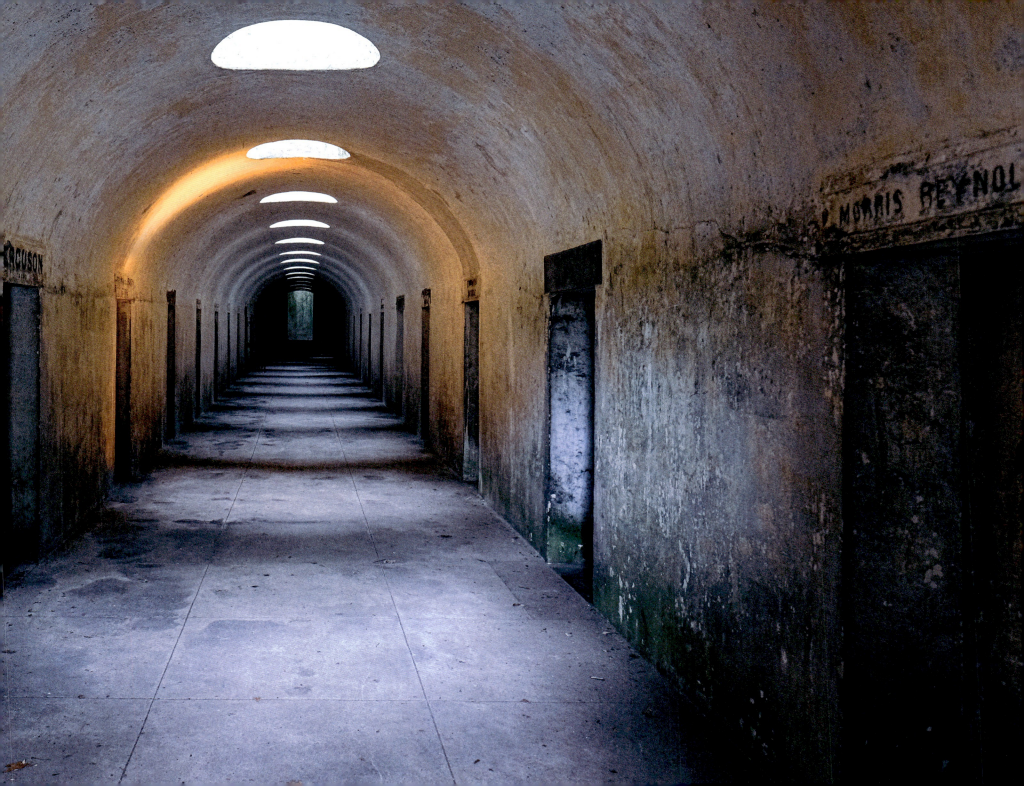

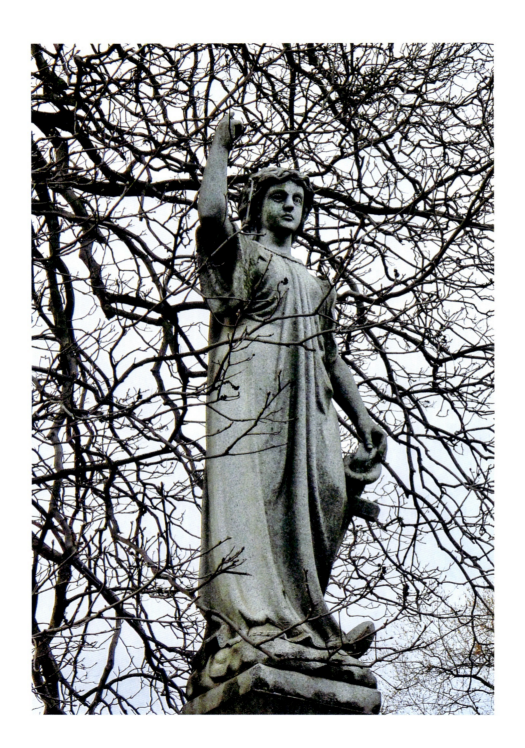

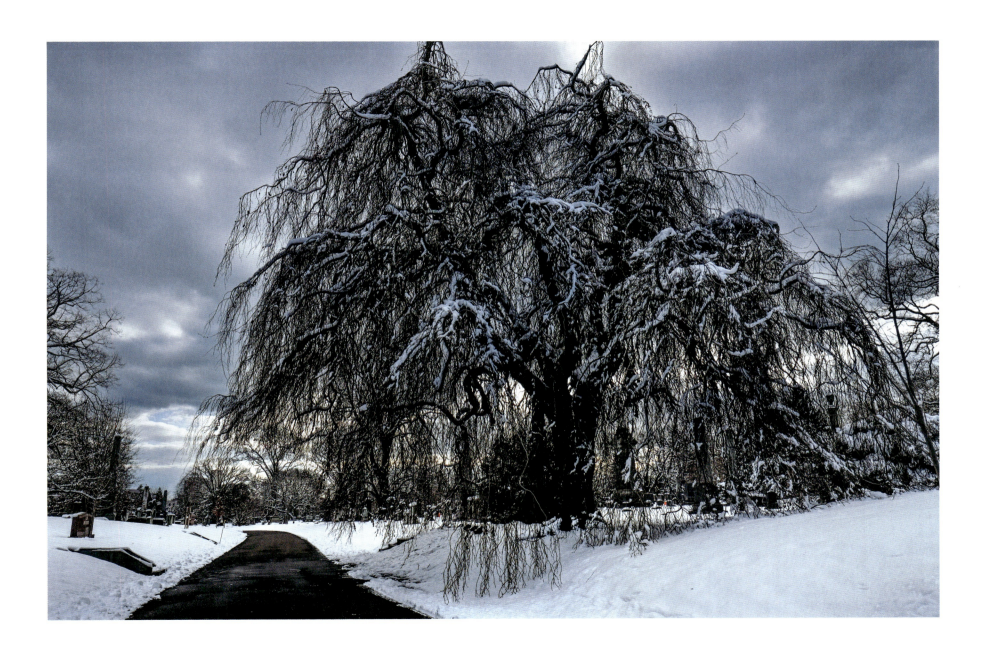

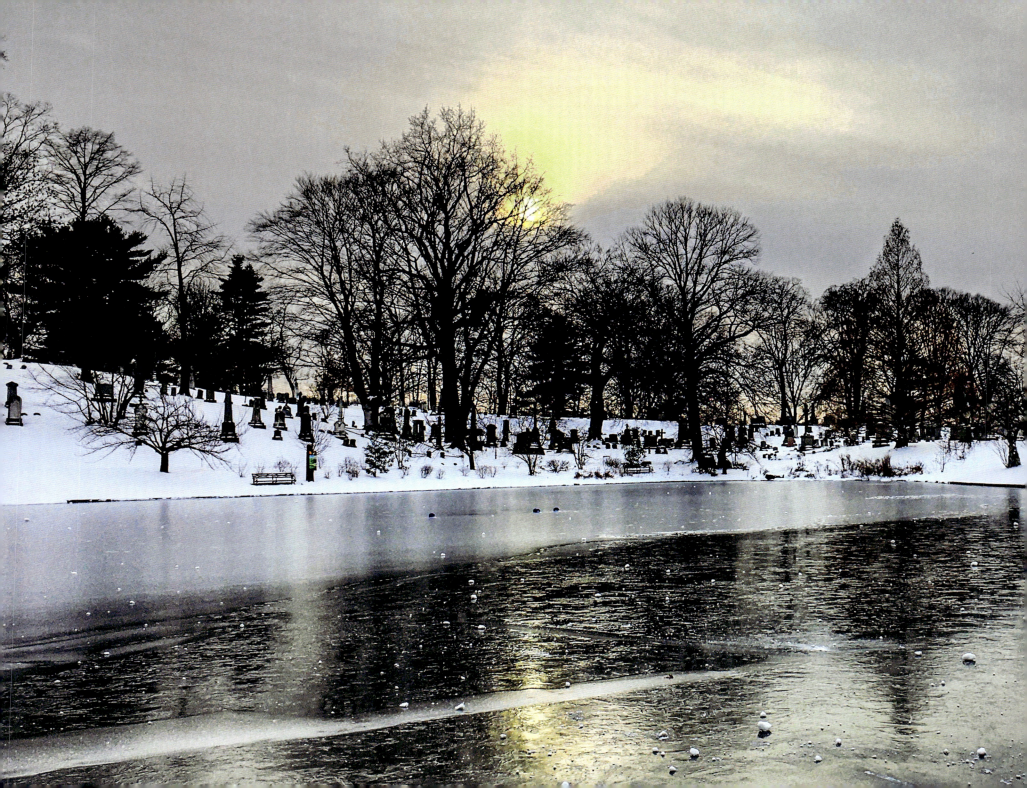

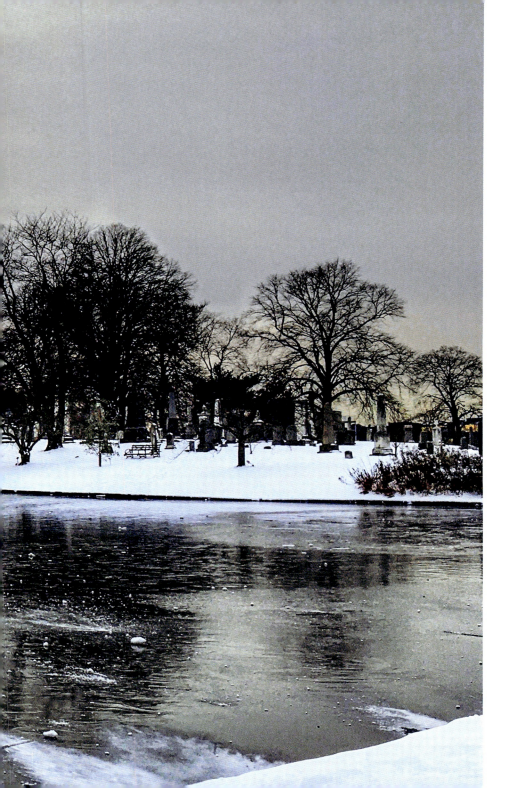

A gesture in stone. The fingers just touching the collarbone. The arm raised, fingers stroking sky. And with two fingers missing, posed as though placed on the head of the child who isn't there. And where go the speaking hands; the hands fly alone, attached by a thread to the body that is gone.

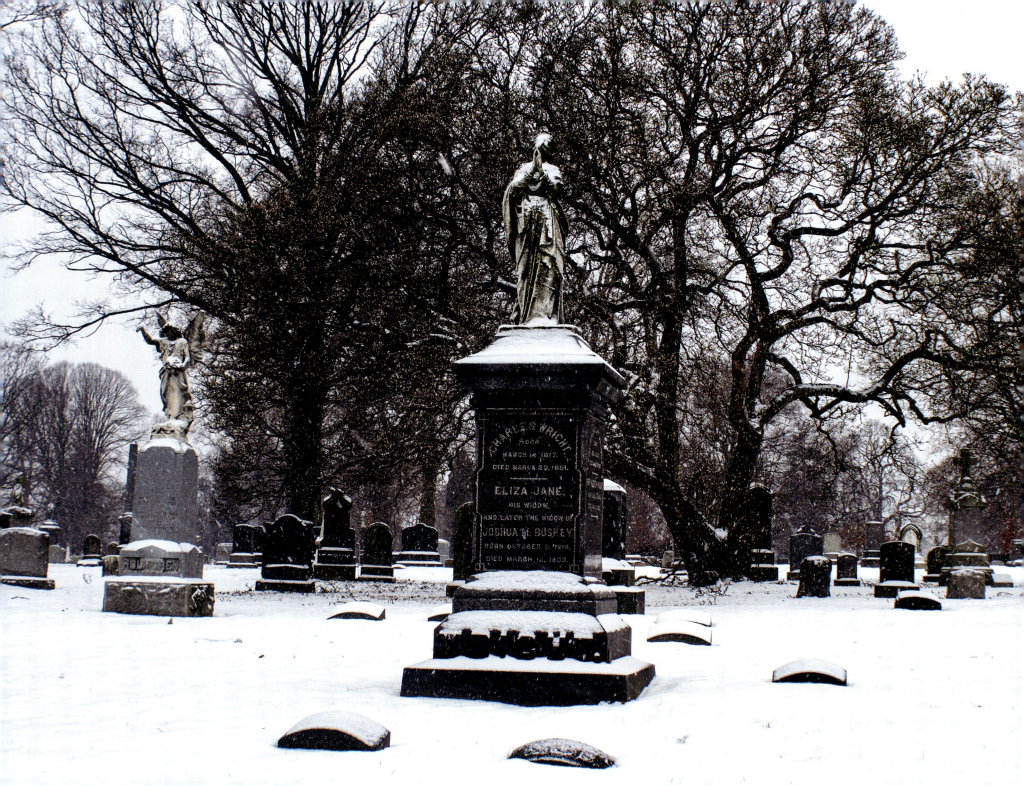

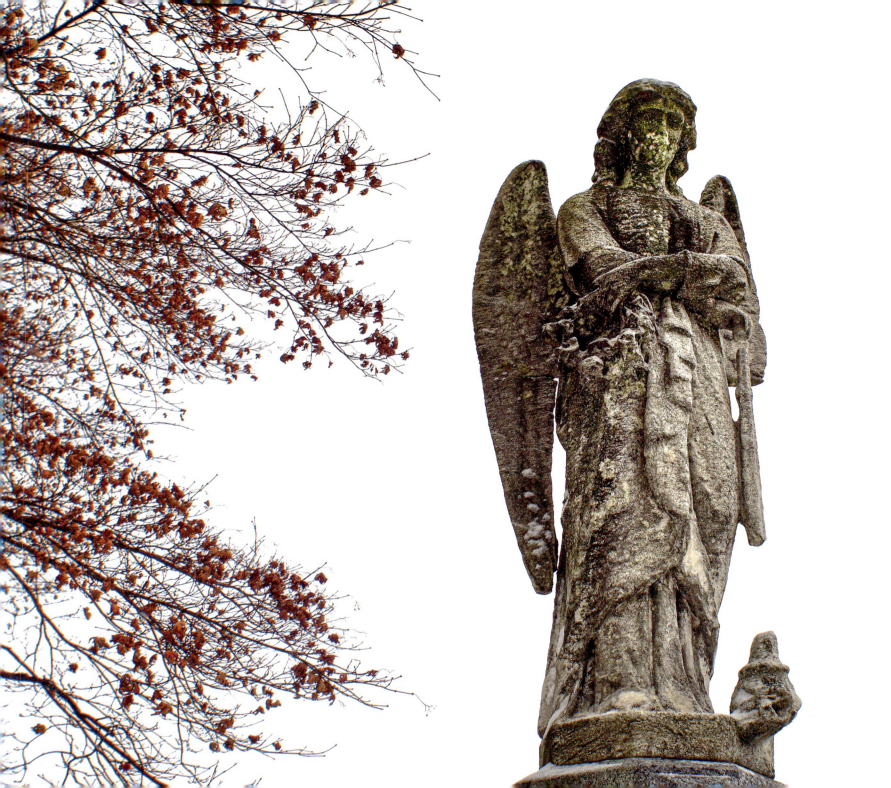

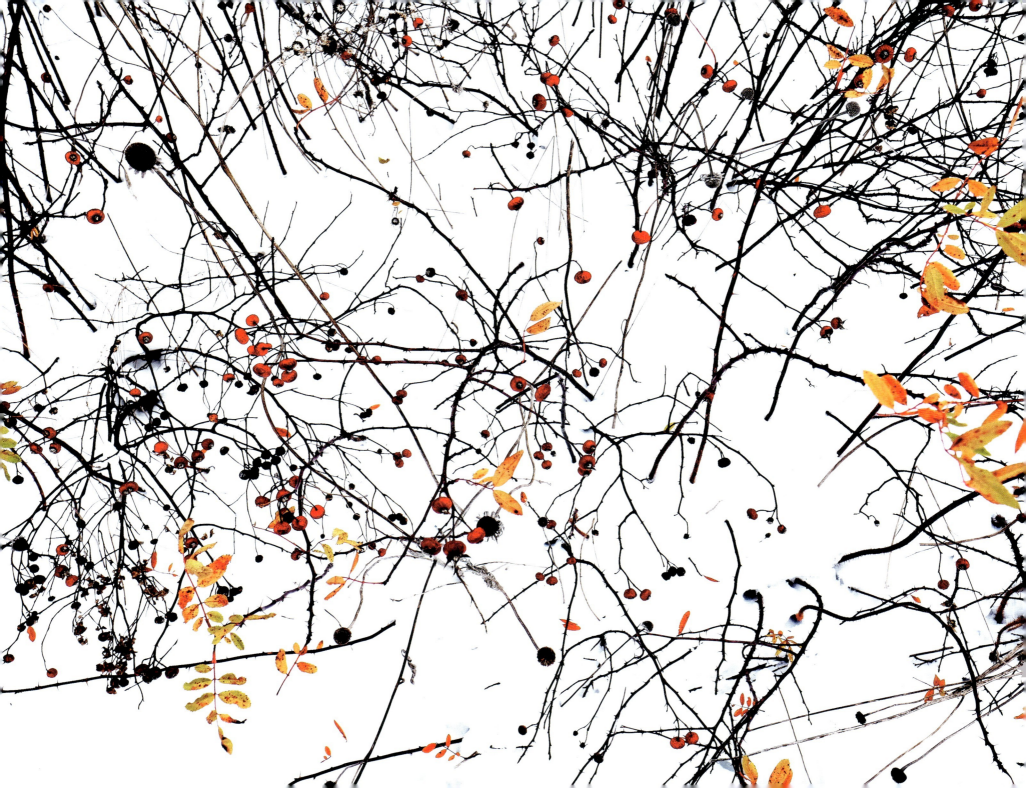

In Buddhism, the hand held up shows itself empty, thus friendly, while also stopping the weight of the world from entering the mind. Here the echo of this gesture, so deeply weathered, seems to absorb time, so that its weight as well is freed from the mind.

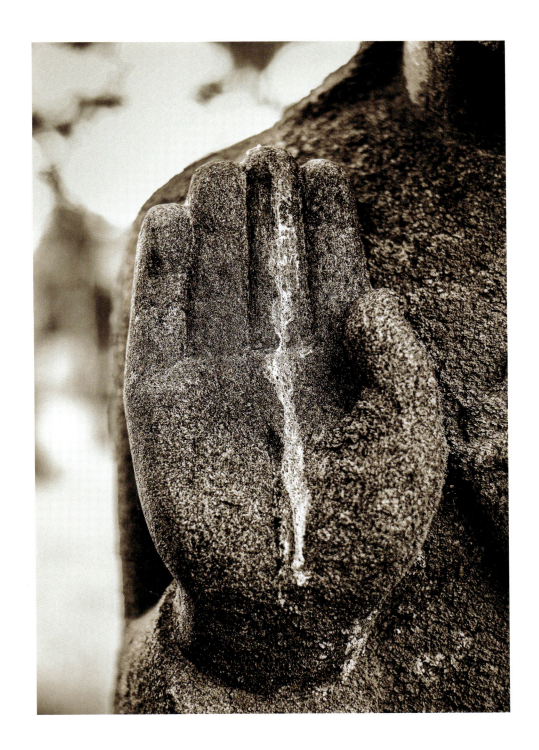

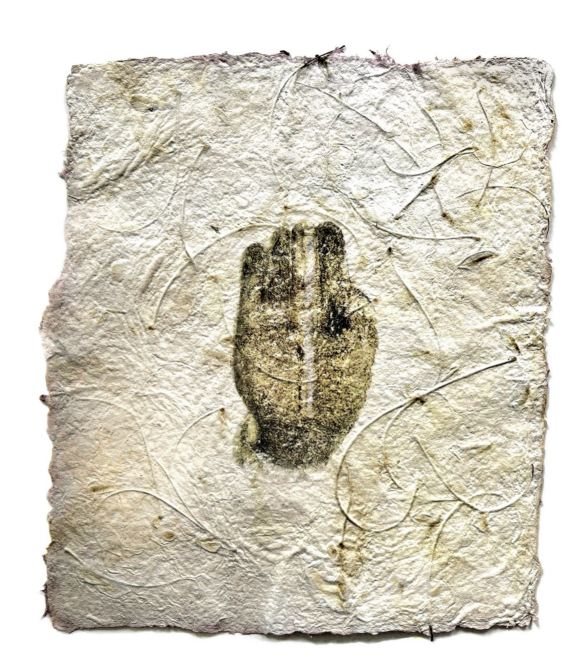

WORKS ON PAPER

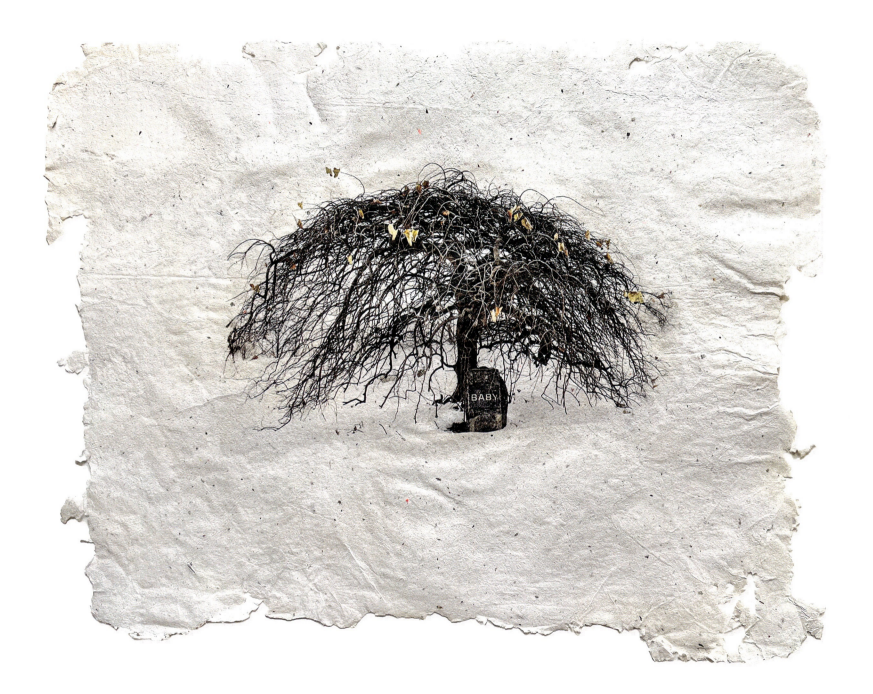

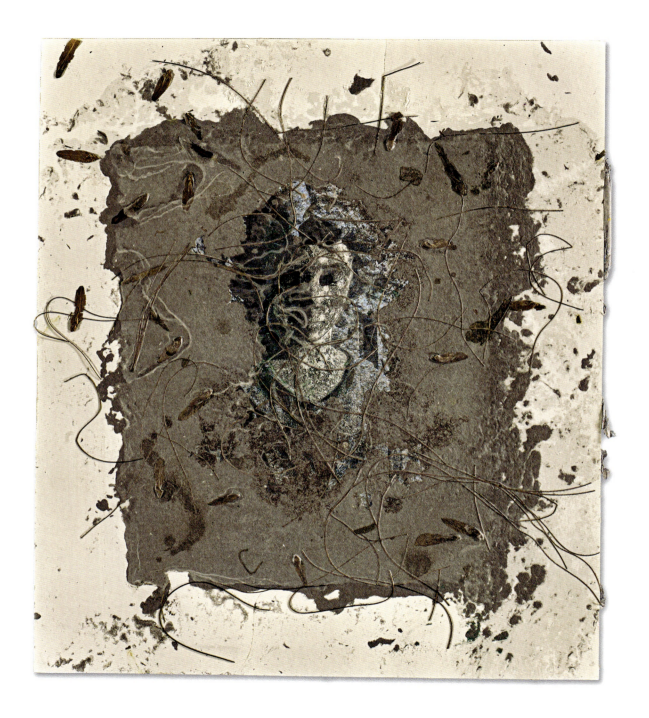

94

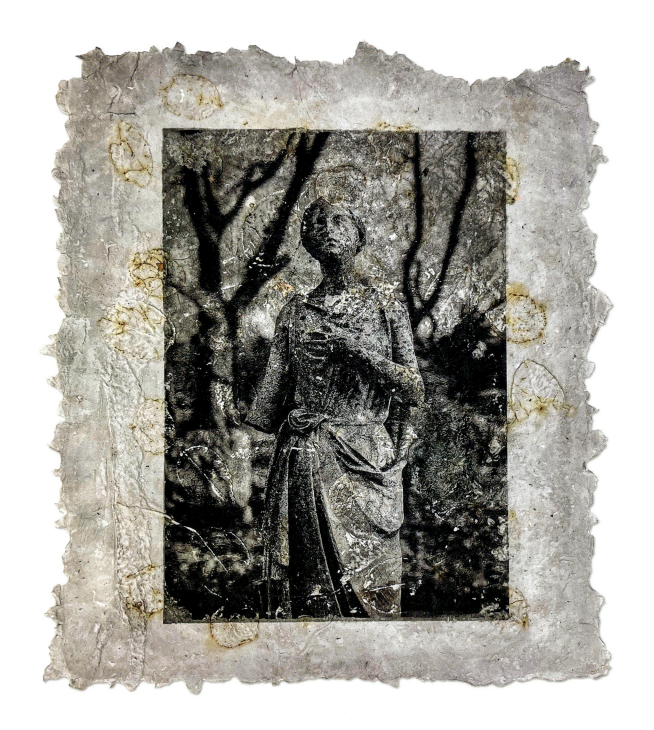

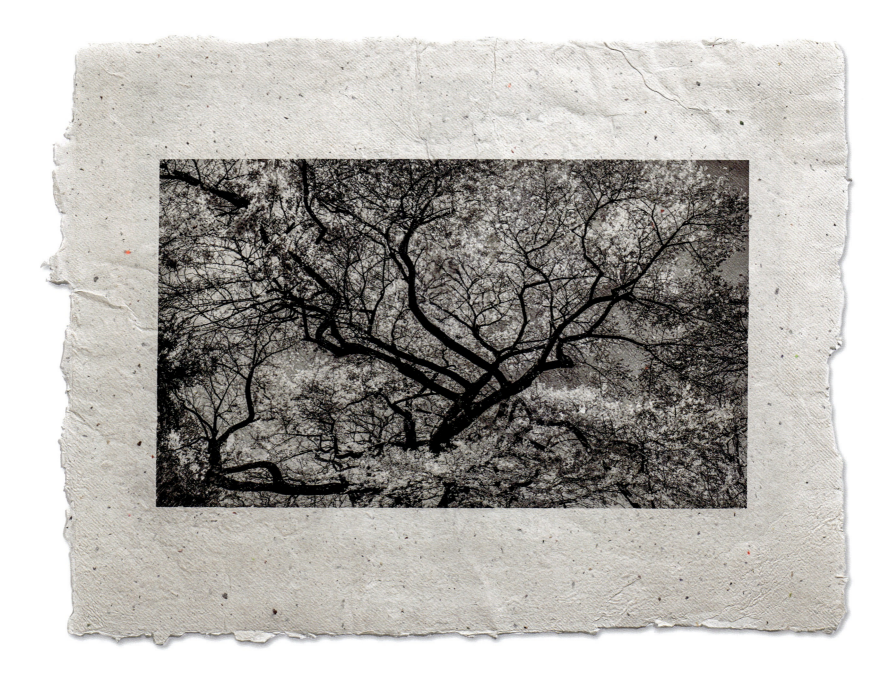

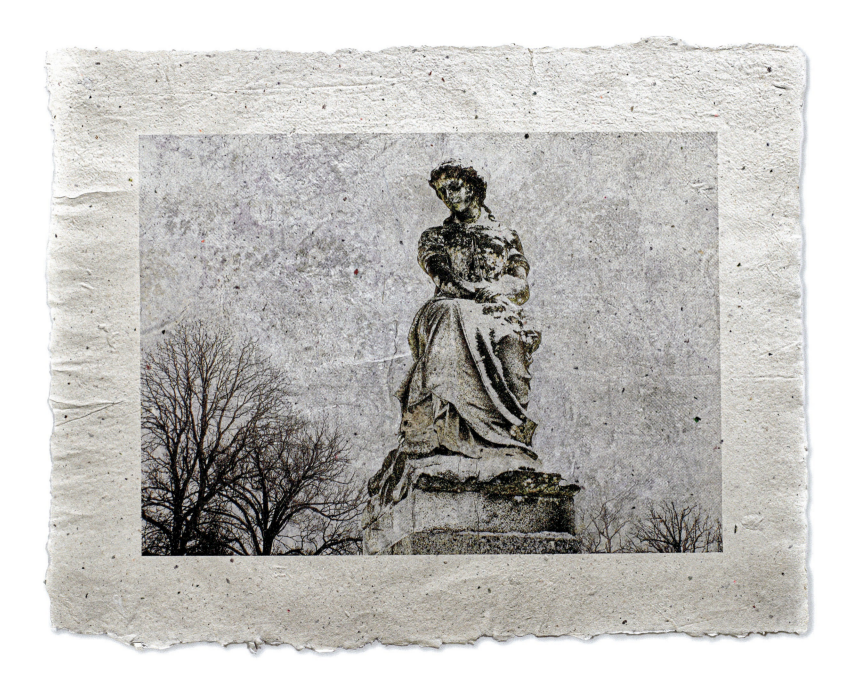

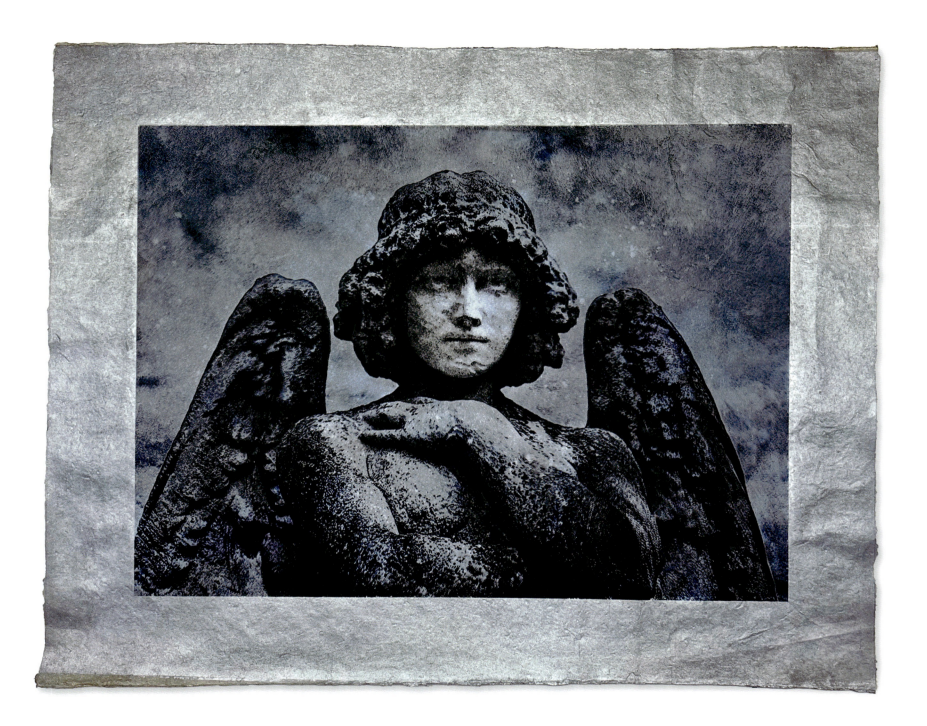

The face becomes some other response to the sun, to rain, to acid rain, to the urge to run. Some other time has come to the face that takes it somewhere else—and the photograph, to somewhere else again. And the face that refuses to go away—it's through the gaze that a being stays, that a being emblazons itself in space.

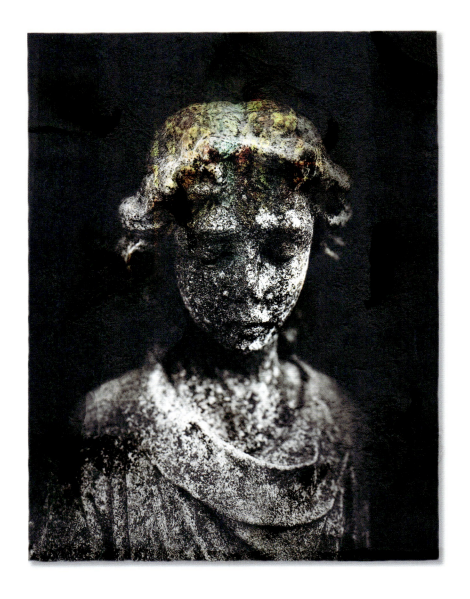

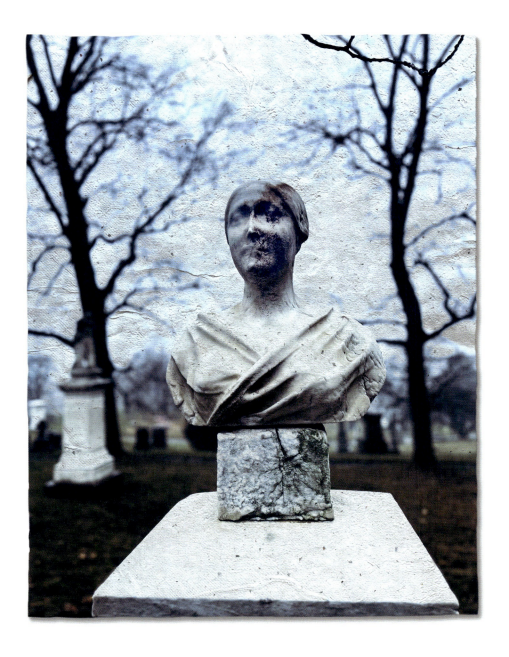

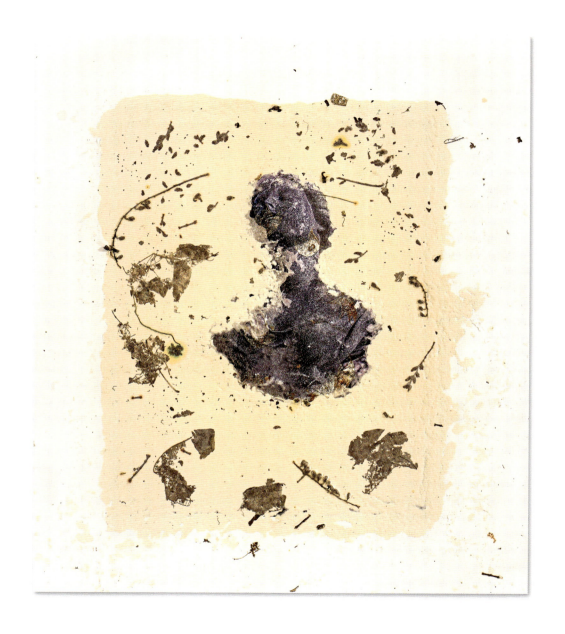

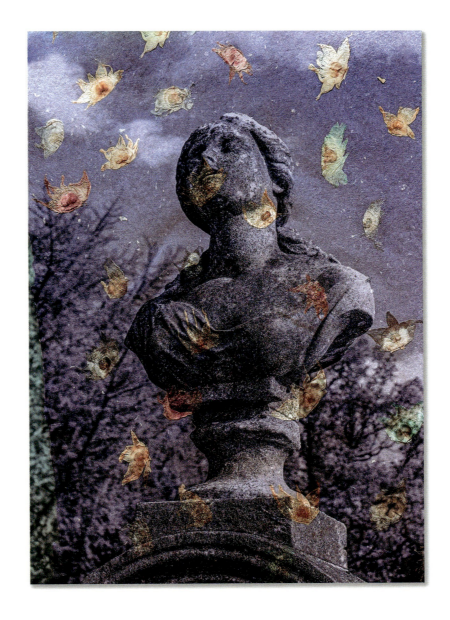

Angel seen from the back, angel of all sight, so we look with it—into the distance, blocked for us in part by the wings—stone wings—rising like the hand. Stop, says the world, coming in—there is no thing here not humming—only heard by ears of stone. And then a bird—and you're back in the world again.

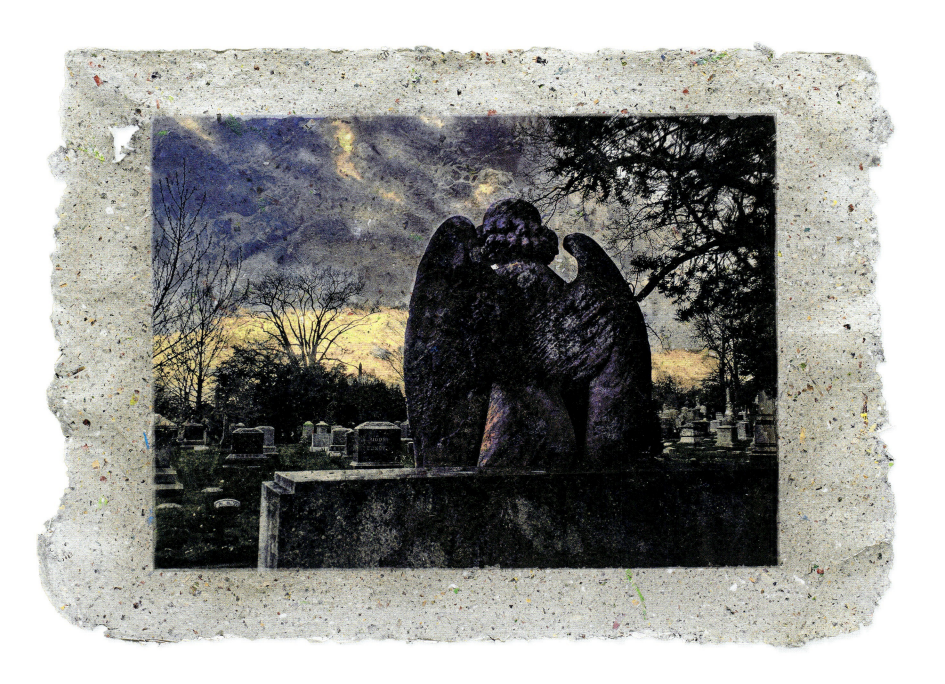

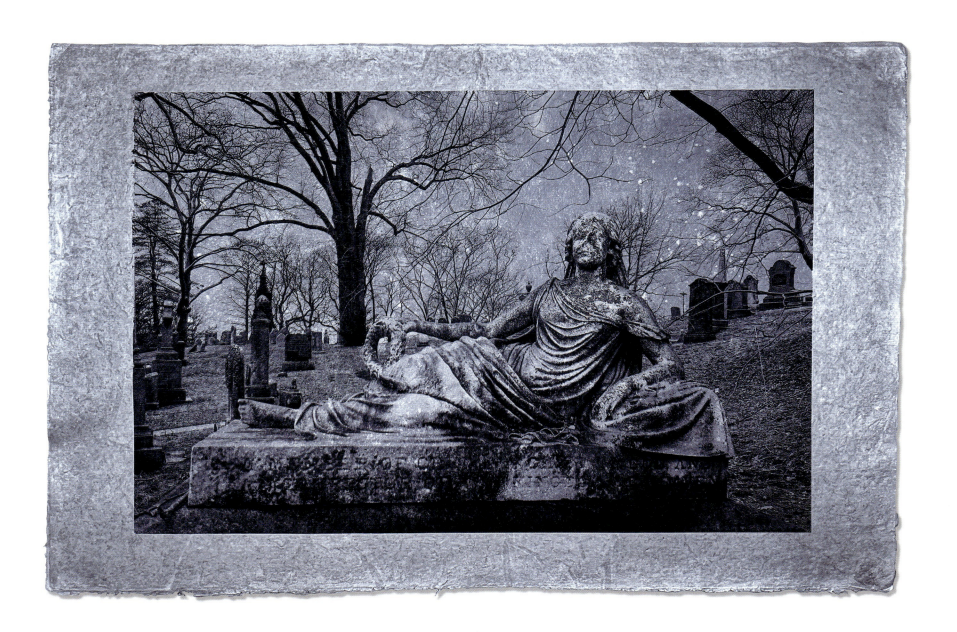

The Transformation of Memory

by Roy Skodnick

Susan Sontag writes in *On Photography*: "All photographs are *memento mori*. To take a photograph is to participate in another person's (or thing's) mortality, vulnerability, mutability. Precisely by slicing out this moment and freezing it, all photographs testify to time's relentless melt." She states that photography as the recording angel of death converts the whole world into a cemetery. Jacobson's photographic transfers on handmade paper take the literal subject of the cemetery and by transforming them into singular works of art reinvest their photographic presence with a materiality that subverts Sontag's equation of photography with death.

In these works on paper the artist's hand is emphatically present. Their surfaces convey an expressive, sensuous reality. "I wanted to explore the tactility of this particular landscape," Jacobson explains. "I learned the art of making handmade paper. I made it with cotton pulp, abaca, newspaper circulars, leaves, stems, and other detritus that I collected on my walks through Green-Wood."

The photographer George Hirose, who co-curated an exhibit of this work observed, "There is an ephemeral spirituality in Bethany's meditations on nature. I have always been interested in photographic transfers as unique objects that transcend the literal descriptions of straight photography. When I learned that these photos were taken during the pandemic, I felt that the marriage of image, process, and place beautifully express a sense of solace that many of us were searching for. This body of work is a faithful poetic reflection of our shared consciousness during those difficult times."

"In the past few years," Jacobson says, "my mother and several close friends died, and then the pandemic hit. It really brought home the fragile reality of our lives. The erosion, layering and the compression of time into a material object is something I was thinking about. Natural elements, grief and memory all came together, leading me to make this primitive kind of paper as a ground for these images." Consider Jacobson's work, *Baby*, which has an image of a headstone inscribed with that powerful word enveloped by the winter branches of a redbud tree. Centered on the irregularly textured cream paper with ragged edges, the paper itself becomes a map and the bare tree a symbol of maternal protection honoring the baby's early death.

Another work, *The Hand*, memorializes both place and seasonal change by isolating a single part of the statue and transferring it to a highly textured paper embedded with stems from the location. Jacobson comments, "What is interesting is that the hand is part of a Christian statue which resembles the Abhaya mudra in Buddhism. Whether by chance or not, there seems to be a universality to this gesture, and for me it expresses something important. The Abhaya mudra is a way of removing fear from your mind. By showing that the hand is empty, the individual shows friendship and peace. The gesture stops the pressures of the outside world from entering the mind."

Jacobson was drawn to the female statuary from the Victorian era in Green-Wood. Time-worn, abandoned to their fate, marble fragments have broken off from these memorials. From summer squalls to winter ice, lichens mottle their once smooth surfaces. The transfer of Jacobson's photographs onto handmade paper adds to the layers of accumulation. Collecting nature's castoffs—petals, leaves, seeds—and embedding them into the pulp, she dramatizes the statuary's metamorphosis and degradation.

Throughout New York City, allegorical statues of triumph and grace adorn public monuments. From angels embellishing fountains to war memorials; such work rarely commemorates individual women. At the end of the nineteenth century, newer types of memorialization emerged, ranging from mass-produced granite headstones ordered through the Sears, Roebuck and Co. catalogue to one-of-a-kind works by major sculptors like Augustus Saint-Gaudens and Daniel Chester French.

In Green-Wood Cemetery there are statues honoring women who lived and died in this city at a time when the haute bourgeoisie could afford to memorialize a loved one. However, male statuary is far more likely to commemorate particular men, while the representation of women tends to be more generic. An example in this series, *Abandoned to Her Fate*, is a portrait of a particular woman, delicately balanced on a plinth with the family name "Schmidt" and "My Wife & Our Mother" carved into the base. Her marble face is scarred by veining due to weathering and physical deterioration, yet distinct enough to see that she was someone of stature.

Jacobson's emphasis on the Christian funerary statuary highlights the angelic presences in Green-Wood. Downcast, mournful or with an ecstatic gaze upward, they appear to ask the living to ignore death and contemplate the afterlife. Cynthia Mills wrote in *Beyond Grief*, "During the late nineteenth century angels moved from biblical and religious

contexts into the mass culture of the industrial world. They proliferated in parks as well as cemeteries and public war memorials and fictional accounts." Paul Gardella's book *American Angels* notes that artists used angels in the late nineteenth century to invoke "spiritual power without dogma, contributing to a new realm of non-denominational religion."

Reclining Lady, a rarity in her prone pose, possibly influenced by Greek sculpture, lies on her deathbed with laurel wreath in hand, a Christian symbol of triumph over death. Jacobson reflects, "I transformed her into a nocturnal sphinx as my homage to the Surrealists and their belief in the irrationality of dreams. These statues have their cultural history, which I could alter suggestively and even irreverently. They were my found objects. I felt as if I could make these mournful women my own by some alchemical transformation." As these artworks provide a photographic interpretation of the statuary, transforming the three-dimensional into image transfers, they become meta-records of the literal photograph, further detaching them from their original physicality in counterpoint to the materiality of the handmade paper.

In Jacobson's *Drifting with Flowers,* the re-photographing of the handmade paper with swirling multicolored petals adds yet another layer, echoing the female gaze toward the heavens, reminding us that typically these women express an otherworldly presence. In the complementary work *Ecstasy*, the layering of pulp, embedded with flowers and twigs, encircles the bust, returning natural elements to her feminine presence. "I wanted the whole thing to feel dreamlike," she says. "Here's this relic, this thing that is left over, even though it's been remade now."

Sontag wrote, "Photography converts the whole world into a cemetery. Photographers, connoisseurs of beauty, are also—wittingly or unwittingly—the recording angels of death." Jacobson's transformation of the female statuary in contrast highlights spiritual qualities that reinvigorate these decaying monuments of grief and loss with a contemporary aspiration for transcendence. Created by occasions of mourning and death, changing with the seasons, each year carving their marks, Jacobson deepens our feeling for the loss of these abandoned memorials and the impermanence of time.

List of Plates

p. 2: Cherry Blossom Valley Water, Landscape Avenue, Spring 2020

p. 4: Magnolia, Spring 2021

pp. 6–7: Dogwood, April 2023

p. 8: Dogwood & Angel, Spring 2023

p. 12: Cherry Blossom, Spring 2023

p. 13: Vine on Gravestone, Spring 2022

pp. 16–17: *Valentine Angel*, sculpture by Adolfo Apolloni (1855–1923), Spring 2020

p. 18: *Minerva* & *Altar to Liberty* (1920), sculpture by Frederick Wellington Ruckstull, commemorating the Battle of Brooklyn, Winter 2022

pp. 20–21: European Beech, Fir Avenue, Summer 2020

p. 22: Mausoleum Bronze Door, Sylvan Water, Summer 2020

p. 23: Cherry Blossom, Spring 2022

pp. 24–25: Cherry Blossom, 2022

p. 26: Floating Branch, Valley Water, Spring 2020

p. 27: Mother/Father Gravestone, Summer 2021

p. 28: Sarah Henderson Monument & Beech Tree, 2020

p. 31: Elderly Lady Walking, Spring 2020

pp. 32–33: Shades of Green, Summer 2021

pp. 34–35: Crescent Water, Blue Atlas Cedar & Mausoleum, 2020

p. 36: Redbud Tree, "Baby" Gravestone & Beehives, Landscape Avenue, Spring 2023

p. 38: European Smoke Tree, Lake Avenue, Spring 2020

p. 39: Azalea Bush, Spring 2020

pp. 40–41: Magnolia Tree, Spring 2021

pp. 42–43: Valley Water Reflection, Spring 2023

pp. 44–45: Cherry Blossoms, Waterside Path, Spring 2023

p. 46: Stained Glass Angel in Mausoleum, Spring 2022

p. 47: Stone Engraving & Red Berries, Fall 2021

pp. 48–49: Japanese Maple, Fall 2021

p. 50: Female Statue & Red Berries, Fall 2021

p. 52: Fall Colors, Sycamore Avenue, 2022

p. 53, Tranquility Garden, Fall 2020

pp. 54–55: Ginkgo Tree, Vista Avenue, Fall 2023

pp. 56–57: Japanese Maple & James Renwick Jr. Mausoleum, Spring 2022

p. 58: Japanese Maple, Spring 2020

p. 59: Huber Monument, Garland Avenue, Fall 2013

pp. 60–61: Woman Walking, Vine Avenue, Winter 2022

p. 63: Female Statue, Spring 2020

p. 64: Sunset & Statuary, Border Avenue, Spring 2020

p. 66: Mother & Daughter Statue, Winter 2022

pp. 68-69: The Catacombs (1850s), Winter 2022

p: 70: "Love" Gravestone, Canna Path, Winter 2022

pp. 72–73: Angel & Tree in Fog, Chrysanthemum Path, Winter 2022

pp. 74–75: The Hill of Graves, Spring 2020

p. 76: The Catacombs, Winter 2024

p. 77: Monument in Winter 2020

p. 78: Weeping Beech, Winter 2024

pp. 80–81: Sylvan Water, Winter 2020

p. 82: Eliza Jane Memorial, Winter 2013

p. 84: Angel Statuary, Winter 2013

p. 87: Red Berries, Yellow Leaves, Winter 2020

p. 89: Hand with Bird Dropping, Spring 2020

Works on Handmade Paper

p. 90: *Hand*, 2023, image transfer on handmade paper with stems, 23 × 28 in.

p. 93: *Baby*, 2023, image transfer on handmade paper, 24 × 30 in.

p. 94: *Sound of Wind*, 2023, paper pulp, natural inclusions, pigment print, 20 × 24 in.

p. 95: *Broken Arm*, 2023, image transfer on handmade paper, 20 × 24 in.

p. 96: *Tree*, 2023, image transfer on handmade paper, 24 × 30 in.

p. 97: *Victorian Lady*, 2023, image transfer on handmade paper, 20 × 24 in.

p. 98: *Ad Infinitum*, 2023, image transfer on Thai silver paper, 20 × 24 in.

p. 100: *Mourning Angel*, 2023, image transfer on Japanese Kozo paper, 20 × 24 in.

p. 101: *Abandoned to Her Fate*, 2023, image transfer on Japanese Kozo paper, 16 × 20 in.

p. 102: *Ecstasy*, 2023, paper pulp, natural inclusions, inkjet print, 20 × 24 in.

p. 103: *Drifting Flowers*, 2023, pigment print on archival paper, 18 × 24 in.

p. 105: *When the Sky Darkens*, 2023, image transfer on handmade paper, 24 × 30 in.

p. 106: *Reclining Lady*, 2023, image transfer on Thai silver paper, 22 × 32 in.

Contributors

Bethany Eden Jacobson is a photographer and filmmaker. A native New Yorker, she studied art from an early age. In the 1980s, she worked as a photojournalist, photographing such seminal figures as Wim Wenders, David Wojnarowicz, Iggy Pop, and Chantal Akerman for a variety of publications. She went on to study film and worked in the film business for many years. She has written and directed award-winning films which have been screened internationally. In the past five years, she returned to her passion for photography. Most recently, her focus has been on exploring alternative processes. Her work has been in group and solo exhibitions including: The Third Barcelona Foto Biennale in 2022; Gallery Onetwentyeight, New York City, in 2022; and E.V. Gallery, New York City, in 2023. She currently teaches at Pratt Institute and Brooklyn College.

Cole Swensen is the author of 19 books of poetry, most recently *And And And* (Shearsman Books, 2023), a collection of hybrid lyric essays on landscape art, *Art in Time* (Nightboat Books, 2021), and a volume of critical essays, *Noise That Stays Noise* (University of Michigan Press, 2011). A former Guggenheim Fellow and recipient of the Iowa Poetry Prize, the SF State Poetry Center Book Award, the National Poetry Series, and the PEN USA Award in translation, she has also been a finalist for the National Book Award, the *Los Angeles Times* Book Prize, and the Griffin Poetry Prize. She translates poetry and art criticism from French and divides her time between France and the US.

Roy Skodnick was the editor of *All Area*, a journal on method and place, that published work by Charles Olson, Kenneth Burke and Julia Kristeva. He has written on Miguel Algarín and the Nuyorican Poets Café, artist Frank Gillette, and Radical Software. He is the author of *True Son of Hephaestus: James Metcalf*. He curated exhibitions of Metcalf's artistic collaboration with sculptor Ana Pellicer and the coppersmiths of Santa Clara del Cobre in Michoacán, Mexico. These include: The Hispanic Institute, New York City; Miguel Abreu Gallery, New York City; Kasmin Gallery, New York City; Hispanic Institute, New York City; Temple Gallery, Philadelphia; and Mexican Cultural Institute, Washington, DC.

Art Presson has worked in various positions at Green-Wood since 2006. Most significantly, he has served as Vice President of Design and Landscape. During his tenure, Presson has elevated Green-Wood's focus on horticulture, planted 2,100 trees, and helped it become a Level III Arboretum. Early in his career, Presson worked for the legendary photographer and founder of the International Center of Photography (ICP) Cornell Capa. At ICP, he designed exhibitions of work by David Hockney, Annie Leibovitz, Henri Cartier-Bresson, Margaret Bourke-White, Robert Capa, Sebastião Salgado, W. Eugene Smith, and many others.

Acknowledgments

Thank you

To my parents, who supported my creativity from an early age. My mother, Sally, loved the arts and believed in my artistic spirit. My father, whose gift of a Leica IIIf in my teens inspired my love of the medium. My sister, Lisa, an avid art collector, continues to engage me with her savvy insights about photography. And to my daughter Zoe, your perception and intelligence inspire me every day.

Thank you

I am indebted to photography mentor Douglas Stockdale, whose unwavering support and expertise helped me grasp the intricacies of sequencing and editing a book. Thomas Halaczinsky, many thanks for your practical advice on photography book publishing and to Andrea Miller, a great supporter of the arts, for her continued belief in me. Deep gratitude to artists: David Higginbotham, Robert Watlington, Sylvain Durand, Farras Abdelnour, George Hirose, Stefanie Dworkin, and Natalia Neszuu for creating a community over the years. A special acknowledgment to Garret White, poet, photography editor and friend, whose understanding and passion for photography was contagious.

Thank you

Cole Swensen, your poetic text gave another dimension to the book, and taught me how words juxtaposed with images can become alchemical. Many thanks, Art Presson and Roy Skodnick, for your insightful essays through many revisions. Hannah Alderfer, your design magic throughout our collaboration brought the book to a place I could not have envisioned. Chelsey Brandis, your smile and enthusiasm were steadfast during the crowdfunding and production phase of the book. Lastly, I am enormously grateful to the numerous Kickstarter contributors who believed in this project and to The Faculty Development Fund at Pratt Institute for their support.

Published by:
Hirmer Verlag
Bayerstrasse 57–59, 80335 Munich, Germany
www.hirmerpublishers.com

Photography: Bethany Eden Jacobson
Authors: Art Presson; Cole Swensen; Roy Skodnick
Design: HHA design, Hannah Alderfer

Senior Editor at Hirmer Publishers: Elisabeth Rochau-Shalem
Project Manager at Hirmer Publishers: Rainer Arnold
Pre-press and lithography: Reproline Mediateam, Munich
Printing and Binding: Printer Trento s.r.l.
Printed in Italy
Paper: Garda Ultramatt 170 g/m²

Library of Congress Number: 20249097000

The Deutsche Nationalbibliothek lists this publication in the Deutsche Nationalbibliografie; detailed bibliographic data is available on the Internet at https://dnb.de.

ISBN: 978-3-7774-4364-5